Gio Swaby

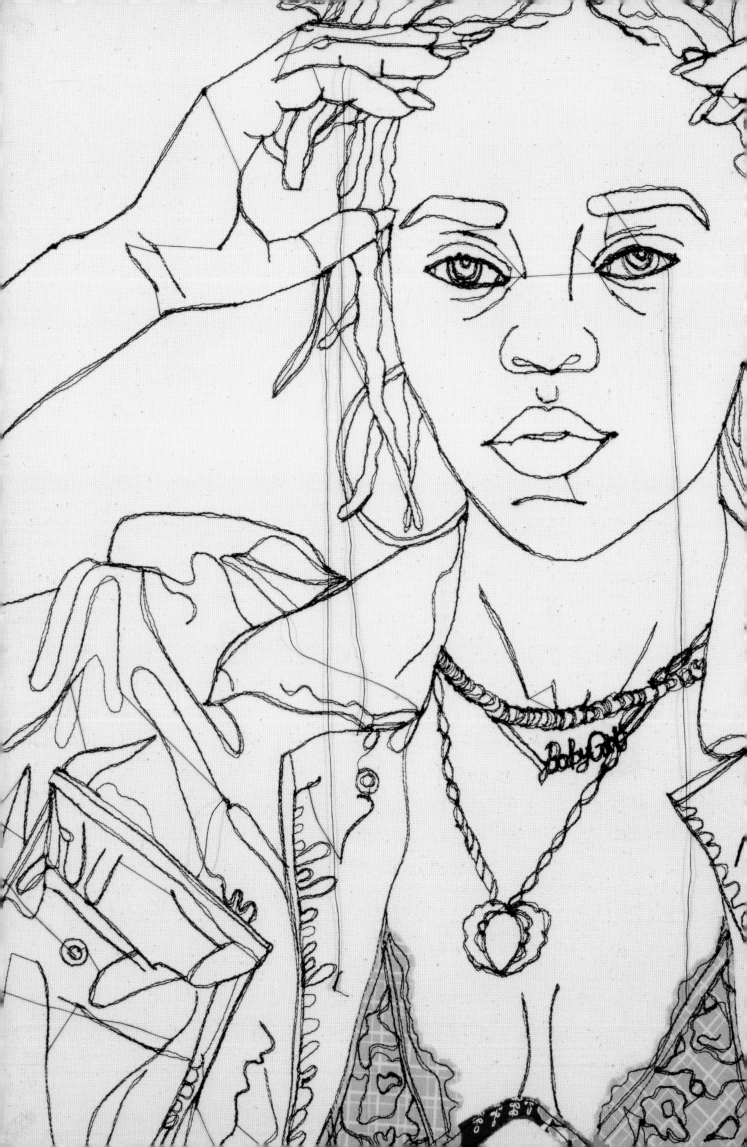

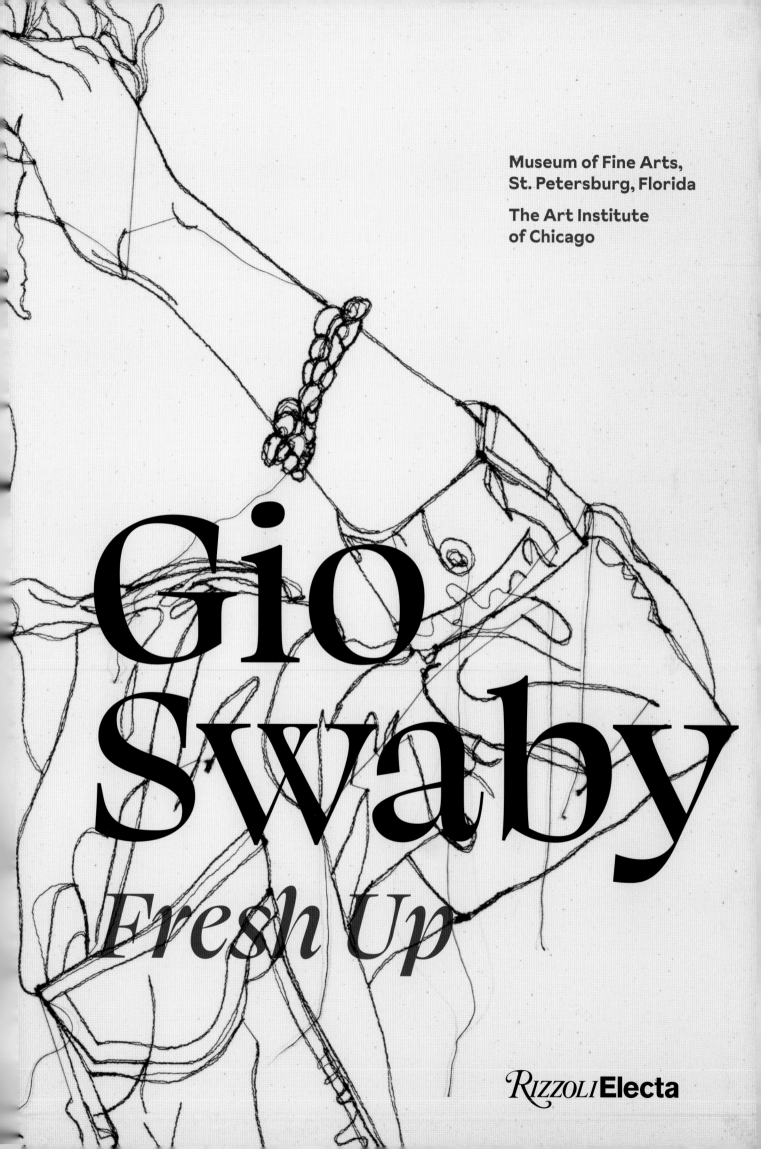

Museum of Fine Arts,
St. Petersburg, Florida

The Art Institute
of Chicago

Gio
Swaby

Fresh Up

RIZZOLI Electa

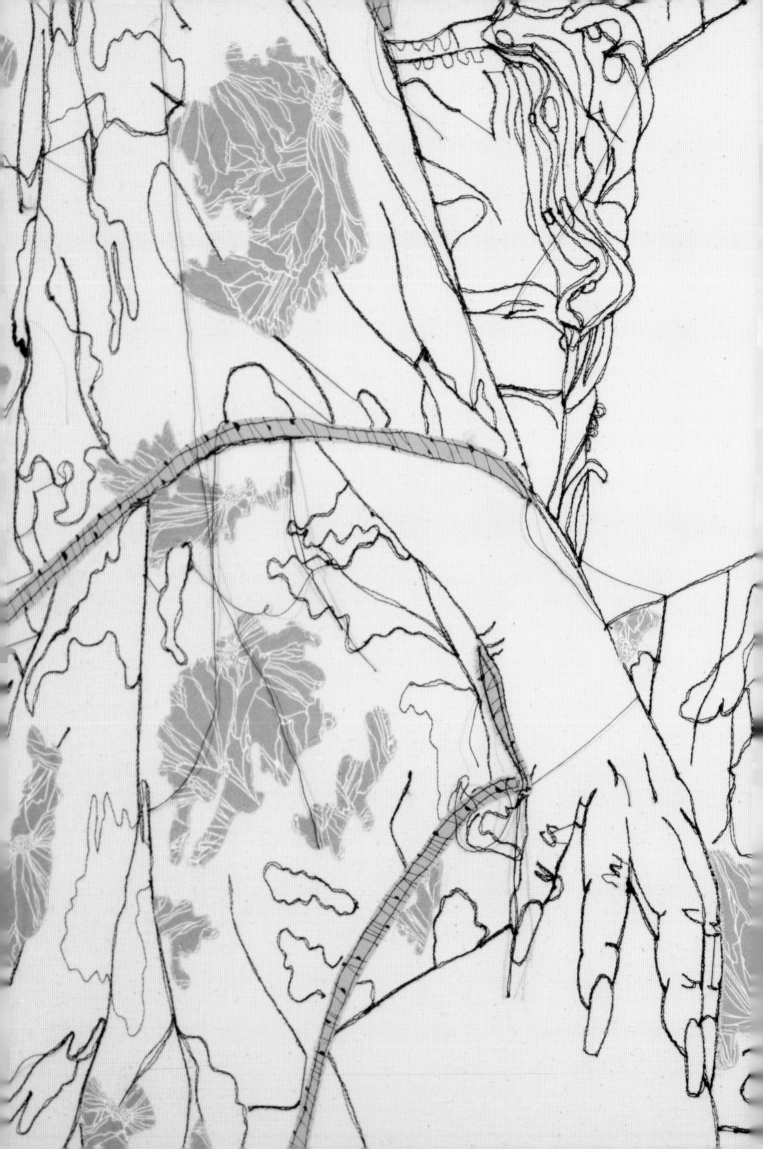

Contents

Directors' Foreword

The Museum of Fine Arts, St. Petersburg and the Art Institute of Chicago are proud to collaborate on Gio Swaby's solo museum debut and to share her work with audiences in the United States. Swaby (b. 1991), a Bahamian currently working in Toronto, has garnered significant attention for her powerful portraits of Black women. These works have their roots in the personal connections—between subject and artist, portrait and viewer—that are a driving force behind her practice. While Swaby draws her sitters from her own tight social circle, she invites us to engage with these young women, whose confident demeanor upends typical power dynamics between the observer and the observed.

Swaby's methodology, which involves fiber art, photography, and social inter-action, is rooted in a form of portraiture she calls "love letters to Black women." She has described her multidimensional depictions as a restorative form of resistance that counters the prevailing tendency to present generalizations about Black lives. At the same time, her portraits are both a gift and a celebration: Swaby explains that *Fresh Up*, the exhibition's subtitle, is "a Bahamian way to describe something that is cool or stylish or a way to give props to someone. I liked the uplifting nature of this phrase."

Swaby also belongs to a tradition of women artists pushing against an aesthetic hierarchy that undervalues both textile and craft traditions. She uses simple elements—sewing thread and modest printed cotton fabrics—to create striking images that convey power, self-assurance, and personal style. Strategically employing these materials, she makes her works accessible to audiences who might be unfamiliar with or uncomfortable in art museum settings.

This project has been realized in collaboration with the artist herself, and we are indebted to co-curators Katherine Pill of the Museum of Fine Arts, St. Petersburg, and Melinda Watt at the Art Institute of Chicago for the inspired way in which they have nurtured this relationship from inception to completion. Our lead sponsors' generosity made the exhibition and the publication of this catalogue possible, and we are grateful to the Elizabeth F. Cheney Foundation, the Collectors Circle of the Museum of Fine Arts, the Garth Family Foun-dation, the Gobioff Foundation, the Sonia Raymund Foundation, and James G. Sweeny. Most importantly, we offer our deepest thanks to Gio Swaby for trusting us with her solo institutional debut. Swaby is part of a generation of artists dedicated to increasing the presence of Black subjects and makers in museums, an effort that our institutions ardently support.

Kristen A. Shepherd, Executive Director and CEO Museum of Fine Arts, St. Petersburg

James Rondeau, President and Eloise W. Martin Director The Art Institute of Chicago

Acknowledgments

In our dual roles as authors and curators, we are honored to have the opportunity to work with artist Gio Swaby and to craft this publication alongside her first solo museum exhibition tour. Swaby embarked on this collaboration with great generosity, bringing her keen artistic vision to every aspect of the project.

We thank Nikole Hannah-Jones for her elucidating interview with Swaby, which provides ample background to the artist's practice and career trajectory, and a frank discussion of the art world's inaccessibility. Our own essays strive to contextualize Swaby's work in both contemporary portraiture practice and the textile arts. In identifying Swaby as a multidisciplinary artist, we have tried to resist rigid categorizations, instead drawing parallels with contemporaries, particularly those whom Swaby cites as influential.

This exhibition would not be possible without the generosity of our lenders. They have enabled us to share a fuller picture of the artist's oeuvre to date and we are profoundly grateful: The Altman Family, Jarrett and Miriam Annenberg; Lisa and Etienne Boillot; Drs. Annette and Anthony Brissett; Susan Chapman-Hughes and Christopher Hughes; Bill and Christy Gautreaux; Roxane Gay and Debbie Millman; Hill Harper; J. Sanford Miller and Ella Qing Hou; the Minneapolis Institute of Art; Rasheed Newson and Jonathan Ruane; Claire Oliver and Ian Rubinstein; CCH Pounder; Quattlebaum/ McCaughey Art Collection; Jason Reynolds; D'Rita and Robbie Robinson; Yolonda Ross; Tatiana Roth; the Weisman Art Museum; and Scott and Cissy Wolfe.

The gallerists Claire Oliver and Ian Rubinstein have sustained this project from its inception; they also provided the excellent images of Swaby's work.

We realized this exhibition with the collegial support of colleagues across our institutions—without them this project could not have come to fruition. At the Museum of Fine Arts, St. Petersburg, Bridget Bryson oversaw this publication and managed details of the exhibition's tour. The MFA's registration team of Ashley Burke and Rachel Rydquist managed the care of the artworks and all logistical details for the tour. At the Art Institute of Chicago, we thank Megan Rader and Kylie Escudero in Exhibitions; the Textiles department and conservation team of Katherine Andereck, Esther Espino, Isaac Facio, and Elizabeth Pope provided crucial support; in Publishing, Greg Nosan, Lisa Meyerowitz, and Emily Fry consulted on the texts; Eve Jeffers, Senior Vice President for External Affairs and her colleagues have helped to bring this project to a broader audience. The guidance of Sarah Guernsey, Deputy Director and Senior Vice President for Curatorial Affairs and Ann Goldstein, Deputy Director and Chair and Dittmer Curator of Modern and Contemporary Art has been equally valuable. And last but not least, we are grateful for the continuing support that museum directors James Rondeau, President and Eloise W. Martin Director, and Kristen Shepherd, Executive Director and CEO, have shown to both of us in this endeavor.

The publishing team at Rizzoli was led by Margaret Rennolds Chace, Associate Publisher, Rizzoli Electa; and Ellen Cohen, Editor. They partnered with us, and designer Barbara Glauber of Heavy Meta to create innovative ways of presenting Swaby's work in print. In closing, on behalf of everyone who contributed to this publication, we are pleased to present this first look at Gio Swaby's work.

Katherine Pill
Curator of Contemporary Art, Museum of Fine Arts, St. Petersburg

Melinda Watt
Chair and Christa C. Mayer Thurman Curator, Textiles, The Art Institute of Chicago

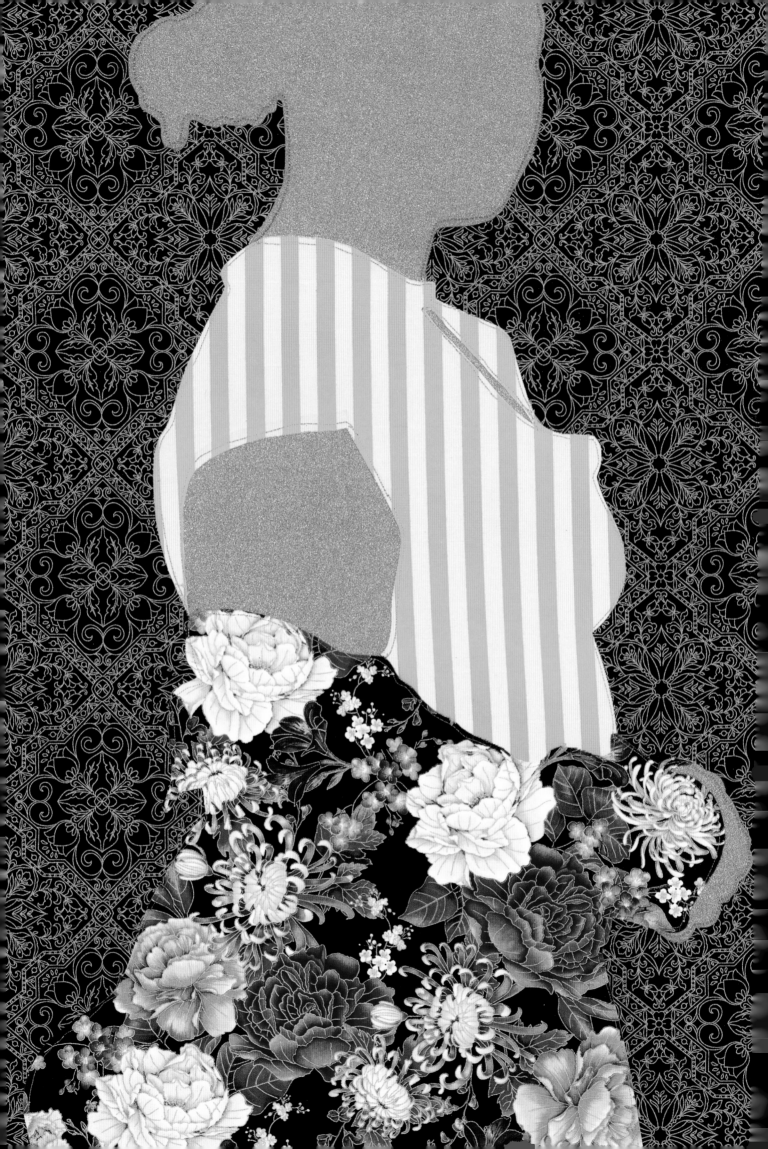

Nikole Hannah-Jones *in Conversation with* Gio Swaby

I did not grow up in a household that discussed art. My family did not go to art museums and no coffee table books filled with the work of Impressionists or abstract artists adorned our tables. What little I learned about famous artists and techniques in my youth, I learned in art class in public school. My people were working class, living in a flyover state, and while we liked to beautify our homes, no one would consider the framed prints from Kmart or the tapestries my grandmother sewed high art.

As an adult, as I met people who'd grown up differently than I had, began working at newspapers and reading more widely, and moved to more cosmopolitan cities, I was more exposed to art and artists and the idea of high culture. But for me, so much of the construct of art museums, and the art world, seems to be built around the value of exclusion. From the price point to get into a museum, to the fact that galleries often did not list the prices of the work or share how one purchases art, to the way people would fawn over a work of art that to me seemed nothing more than a plain line painted across a canvas, to how white the audiences at exhibits were, to how those exhibits almost never featured artists who looked like me or art that reflected my world, I always felt that so much of the "art world" existed to reinforce hierarchies.

Still, art has always compelled me. Even as I rejected the hierarchies of this world, I was drawn to beautiful works of art, whether in books, in exhibits, or on the murals in my low-income Black neighborhoods. I was particularly entranced by protest art, art by Black artists, and art by Black artists depicting the Black experience. Slowly, I began to purchase art, first in Black countries abroad where I felt more comfortable asking about price and selecting art not because someone said the artist mattered, but because it pleased me, and then at small Black art fairs in the United States, and then,

Detail of *Love Letter 5*, 2021

eventually, from more established Black artists, many of whom I found on Instagram. Those artists referred to me as a collector, but I have always felt self-conscious about that term. Even as my own personal collection grows, I consider myself an unsophisticated collector, one who is not particularly knowledgeable about the art world or about artistic techniques, but who collects because I am deeply moved by art.

And that is why Gio Swaby's art speaks so intensely to me. Instead of reinforcing the outsiderness of a Black girl from working-class roots who did not grow up immersed in high art or high culture, it immediately invited me in. Gio's choice of medium evokes the seamstresses in my own family and the long tradition of quilting in Black communities, of working people who found scraps of leftover fabrics and exquisitely stitched them together into something both beautiful and useful. Gio's chosen subjects, whether rendered in silhouette or outline, evoke the women who nurtured me, who befriended me, who surround me still. Gio's work evokes at once awe and comfort, complexity in a misleadingly simplistic form. It is approachable even as you must pause and admire the sheer artistry, grace, and skill that created it.

As soon as I saw it, I knew two things immediately. First, I had to do everything in my power to add Gio's work to my collection. Second, I had to meet this brilliant woman for myself to discuss how she came to create such magnificent works. I am still working on one of these goals. The following is the fruit of the second.

NIKOLE:
How would you describe your art and the work that you do?

GIO:
I would describe my work first and foremost as an act of love. That's a guiding principle of my practice, to approach from love. It is also about gratitude—expressing gratitude for the Black women closest to me in my life, and also for that greater network of Black women globally from whom I feel like I've learned so much about myself and how I choose to navigate my life. The textile portraits I create are about immortalizing the women I am representing. They are my attempt toward decolonizing portraiture. For me, these physical pieces are not necessarily the work itself. The work is more making connections and growing love. Those portraits are like a dedication to that work, or a residue of that work.

NIKOLE:
There's so much in there that I want to unpack. You talked about the women you represent. Who are these women? Who are you speaking of?

GIO:
Most of the people that I represent are my family and friends, people that I know personally. That felt natural to me because I just have so much love and so much appreciation for them, and my practice felt like a perfect avenue for me to express that. But also, there's a layer that thinks about representation. Even though the work isn't representative of this specific Black woman or Black girl viewer, they can still see themselves reflected. This idea of representation reflects what I'm trying to say about love, when I say I'm expressing it on a more personal level and also on a larger scale. It's very personal, but I want to maintain that connection with a larger community and make sure that there's reciprocity between the work itself, me as the maker, and also the people who will view the work. And when I say the people who will be the work, I'm specifically talking about Black people and especially Black people of marginalized genders.

Who are these women on a more personal level, the women you know in your life? What do they represent to you about your life, your community, and also Black women?

GIO:

They partially represent an important aspect of my practice, which is balance—being able to show that strength and vulnerability, the strong and the soft, and being able to find a place in between that is sustainable. They also represent the sisterhood that we have cultivated. I feel a sisterhood with so many women I've known my entire life, just for a year, or sometimes even just for a minute of having an exchange. These works are representative of the sisterhood that we have built together as Black women, a support system for one another. When I think about it on a personal level, there's a journey that I've come through of learning to love myself. I think I will always be on this journey of unlearning and relearning. I've internalized so much of what I now recognize as a perpetuation of white supremacy and replaced it with personal practices that are rooted in anti-colonialism, love, and care.

NIKOLE:

What were some of those messages that you have been working to undo?

GIO:

Something that comes to mind immediately is rest and joy are a big part of my life, and I am working toward being intentional about finding rest, and also being intentional about finding and creating joy. That's a complex and difficult kind of thing to navigate, especially for Black people, when we think about our histories and what we have to deal with on a daily basis because so many systems are in place that want to

keep us kind of inundated with work. We don't have time to reflect.

NIKOLE:

You talked about wanting to decolonize portraiture. Can you explain what that means to you, and how your work tries to subvert that?

GIO:

Oh, yes. I just want to start out by saying that I don't even know if it is possible to decolonize portraiture, but it's important for me to take those steps toward attempting to do that work, to try to find out. Is it necessary to completely rebuild this thing and start from a new place? Or can I work within existing systems? The landscape is constantly moving and changing. How do I approach that? So much of the art we've seen of Black people, historically, has not been made by Black people. It shows so much suffering and trauma, and I think that seeing ourselves represented like that has a strong negative effect on our mental and emotional health, because we see a version of ourselves reflected in those images. What I'm trying to do is use my practice to combat those images, to create representations that are nuanced and maintain the agency of the sitter. This is a contribution to an ongoing conversation continued by artists like Bisa Butler, Ebony Patterson, and Kehinde Wiley. I'm approaching my practice as an attempt to decolonize portraiture in a way that subverts, or often outright rejects those images that show us at our lowest moments.

NIKOLE:

And your art, at least as far as I know, is only women, right? Talk to me about that decision.

GIO:

This is another decision that just felt natural. My mother was a single mother,

and although my father was a part of my life, I grew up mostly within the influence of my mother and older sisters. My family has a very matriarchal structure. I feel like I was raised by my grandmother, my sisters, my aunts, my mother—all Black women. So, I've always looked to them for guidance, for strength, for support. Because a key focus of my practice is to show gratitude and express love, it feels natural to place Black women at the center of that. I work mostly with textiles through augmented forms of quilting and embroidery—which is historically considered to be women's work. I make a specific choice not to reject that connection to domesticity. I actually want to celebrate that work that often goes unappreciated and unrecognized, like so many parts of womanhood, and that's why I choose to represent women. I also want to make it clear that when I say women, I mean trans women, queer women, and not just cishet women.

NIKOLE:

So, let's talk a little bit about biography. When I finally got to meet you, the woman whose artistry I have much admired, in Brooklyn a few weeks ago, we talked about how I think about art as a kind of novice collector, and how I imagine that part of the decolonization process is about taking something that often, at least in my experience as a Black woman from a working-class-background home, has felt very exclusionary. And certainly, I always felt that art galleries were exclusive, and, sometimes, as if there was some joke being played that people like me were not supposed to get. And we talked about when you go into a space and you see something and it appears to me, or a person like myself, to be a line on a paper, but you are told it is a profound piece of work. If you do not feel that way, somehow it's because you're not smart enough or

cosmopolitan enough. So, I'd like to talk about this as clearly part of what you're doing when you talk about decolonizing. You are featuring regular Black women and regular Black girls and you're using a medium that has been kind of looked down upon as not really fine art or high art. So, I would love to have you talk about your journey. You are a traditionally trained artist, in that you've gone to art school, but you're producing art that to me brings in our community and people coming from a textiles background and using a medium that you grew up with. I would love for you to talk about when you started to conceptualize yourself as an artist and what your first exposure to art was. How was the art you were exposed to different from what you were being taught was art?

GIO:

I like that question a lot, because I was not exposed to art throughout my life. Nobody in my family was what is considered to be a professional artist. When I decided to start my journey toward becoming an artist, I had never been to a gallery. I didn't even know about an art community in the Bahamas. So, I come from that place of not knowing. There are people who have maybe grown up going to art galleries, but that's often not the case for a lot of Black folks. My first exposure was in college. Being from the Caribbean, we are already placed on the outskirts of the art world. So, I was already approaching art from the place of being othered by an international art community. In this sense, I've always approached art from the outside. Being born and raised in Bahamas, you are taught to be adaptive, to work with what you have. You might not have easy access to oil paints or the biggest canvas or these super fancy art materials or much of what would be considered to be real art objects. But we still made art. We used house paint or whatever we had

access to at that moment, and I think that's how I arrived at this place in my practice. It's so much a part of who I am and where I come from.

NIKOLE:
Thank you for that. So, let's talk about your choice of medium. I'm such an admirer of your work because I just think it's beautiful. It speaks to me personally, but it also seems to invite in someone like myself to connect to it. I also come from a family of seamstresses. My grandmother sewed. Every Easter dress we ever wore as kids was sewn by her. I'd love to talk about why you decided to choose this medium and how it is a political statement to use the medium of your mother and of your family and your kinship with craftwork in your practice. So, how did you come to start doing that? And what is the political statement of such a thing?

GIO:
Thank you! My choice of using textiles does come from my mother being a seamstress. I grew up around fabric and thread my whole life. I'm her only child who ever really showed an interest in sewing, in any kind of textile work at all, so that was a very special connection with us. In the time that we spent together creating things, like clothing for my dolls, or that Easter dress for Easter Sunday at church, or my special Christmas dress, or school uniforms, we cultivated so much love between us through creation. Because my practice is an expression of love, textiles feel very fitting and a perfect choice to pursue that.

In thinking of the political statement of using textiles, it is certainly, for me, about a rejection of convention, or what are considered to be high art materials. Some institutions consider my work to be fine art and others consider it to be crafts or decorative arts. It's definitely a conversation that's happening in the art world.

I am making art for Black people, and I want my art to be seen and to make a connection with people who perhaps don't have a strong background in art, or didn't grow up going to art galleries, just as I didn't. I want to make sure my work is accessible and approachable. I think using textiles is a part of that because they're a material we come into contact with every day, throughout our entire lives. Textiles are so interwoven into our lives that they feel more approachable than something you maybe would not ever come into contact with unless you visited an art gallery. That's part of the reason I chose to make my work with this material. It's important to me to create multiple points of access, so that the work can be appreciated on many levels. I have equal appreciation for people who maybe see the work, recognizing the beauty or maybe the skill, or a person who would look at the work and maybe see themselves, or a person who looks at the work and sees it as a political statement. That's what I mean when I talk about having multiple points of entry into the work and not creating a hierarchy of who sees it or who can connect with it. I want to leave some openness there.

NIKOLE:
Can you talk to me about how your work has evolved?

GIO:
A lot has changed. I didn't start out working with textiles at all. The program that I first began with at the College of the Bahamas was just a general arts program, so we learned to work with all different kinds of materials like paint, ceramics, sculpture. I didn't really find textiles until a few years after completing that program. One of the biggest shifts for me and my practice was moving toward working with textiles and connecting with a quilting community

following spread, left to right:
Detail of *Pretty Pretty 5*, 2021
Detail of *Love Letter 4*, 2021

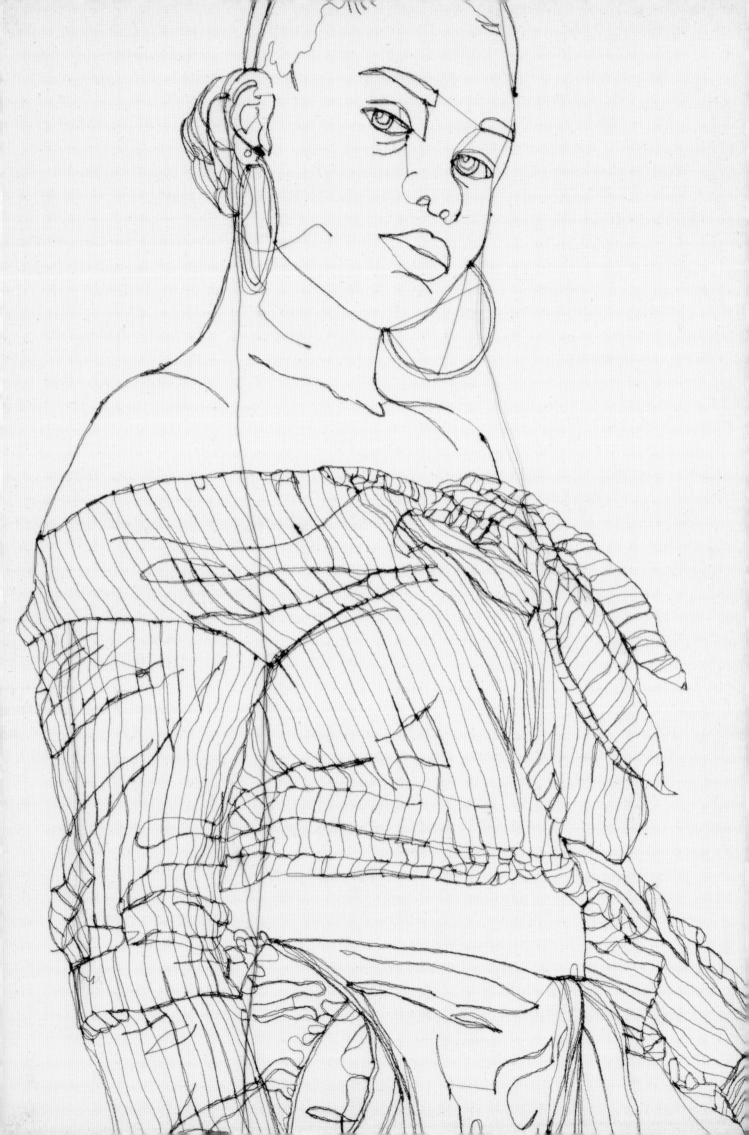

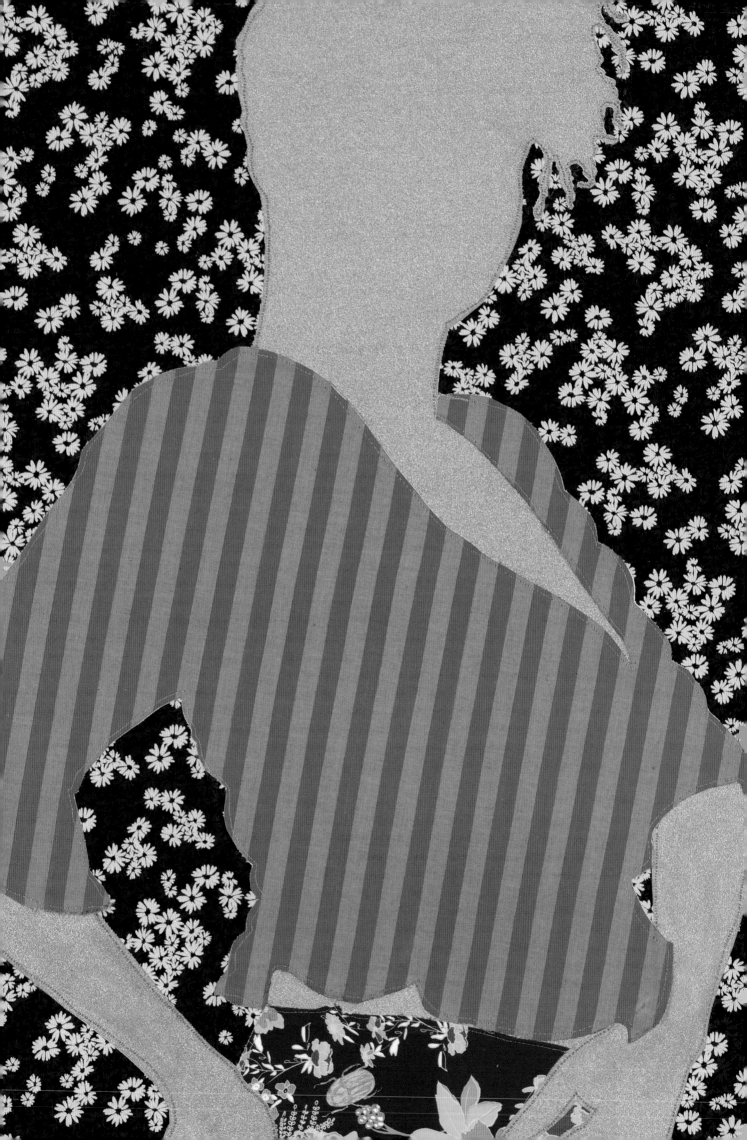

and learning those skills. I draw a lot from quilting practices because I love the way quilters are a community of learners—they're always open to learning, and that's how I approach my practice, because things certainly shift with time. If I look back at something that I made even ten years ago, it means something different to me now. Over the years, I've grown a lot in my sewing skills and I certainly practice and improve my technique, but also I have done a lot of work toward developing my practice conceptually. I have done a lot of reading, a lot of listening and being open to understanding that perhaps what I know right now is not always going to be what I think is the right way to do something. I want always to be learning and growing.

NIKOLE:

You have come on the scene with an intense spark. How does it feel to see your work now, existing in the world, as it is?

GIO:

I mean, it feels incredible, of course. It feels really scary, too, because I know I have a really big responsibility, especially in the kind of work that I'm making. There is an ethical responsibility in representing people. There's a lot of personal responsibility, too, because so many of the people I am representing in my art are people I know personally. It feels amazing, but it's also constantly shifting in my mind. How do I navigate as things are changing so quickly?

But I guess the thing that's been the most exciting for me is seeing images, like with you and your daughter in the gallery in front of my work, just enjoying the space. Also, some of the messages I receive, like, "This is the first time I've seen myself in this way." My audience has expanded so much recently, and I can connect with more people who are able to see the work and

experience it. That's, to me, the greatest gift of all time, especially in regard to young Black girls, because I remember when I was that age how much I wanted just to see myself, how I just wanted to be seen and feel seen. I'm so excited and honored to be able to offer that to someone else.

NIKOLE:

I think that's it. It's profound and also should be obvious. I've been thinking about and writing about this desire to be represented and reflected. When you are a white person who grows up in a world where the art world, media, television, movies, everything reflects you, I think it can be very difficult to understand how demeaning, how erasing it is not to ever see yourself reflected back, and how that leads to these internalized feelings of inferiority. And I mean, to me, this is what makes your work and that of a whole constellation of Black artists so important. It's like you said, you're always looking for yourself and even on television, you're like, "Oh, there's one Black character. At least I'm there."

That is why I brought my daughter to your exhibit and why I'm very careful about what exhibits, what art, what texts I expose her to and ensuring that, yes, of course I want her to see all types of different cultures, but she has to see a significant amount of herself as well.

I do want to touch on this. I wonder if you feel a sense of trepidation that you create this work about Black people and for Black people, but once you have a certain level of mainstream success, you lose a bit of control over it as well. As the price of your art goes up, as demand for your art increases, who can actually own it? Who can have this work of art in their home? It seems like part of success means your art becomes less accessible. And I wonder if you can talk to me about your feelings about that, and what artists can do, because you're making your

living off of this, so its value is important to you. I imagine there is tension between you being able to make a living and having your art valued in the way that it should be, and how that then makes it less accessible to the very community that you are doing this for.

GIO:

Yeah, it's a difficult question. It's extraordinarily complex and it's still new to me. So, it's still something that I am navigating, something that I like to look for advice on from people who have already been through it. I don't think it's something I need to figure out on my own. I'll be honest, I don't really have the answer, but I can tell you my thoughts about it.

For me, accessing art is not just about owning it. It's about viewership, which shifts significantly when you get more attention. At which institutions is your art being seen or being shown? Who actually is attending these shows? It can be a situation where your work brings in viewers who perhaps might not have visited the gallery otherwise, which happened with Bisa Butler at the Art Institute of Chicago. The viewership, the audience, completely changed. So many more Black people came to see that show because it was Bisa and because they knew the kind of work she was making.

You also have to be intentional about creating that invitation for people to come and see your work. Being intentional about language, who your work is for, and how it's represented requires a lot of care and cultivation. How do I make sure that the work is being seen by the people that it's for? It's an extra layer to working as an artist who is Black or any person of color. You have to consider that part.

I'm cognizant that an ordinary person, the average person, cannot purchase my work. Even if you have the money to purchase artwork, if you're a new collector, or you're not historically connected with art, or your family doesn't have this established art collection, at a lot of galleries, you're not allowed to buy their work, you're not allowed to collect it. They will say nothing's available or they'll just straight-up tell you we only sell to collectors who already have an established base.

So, even Black people who have the financial means to collect art are still being excluded, and that's why working with the Claire Oliver Gallery has been such a good opportunity for me, because so much of my work is going to Black collectors and to Black homes. I mentioned to you that a Black collector purchased a series of small portraits and he put them in his daughter's bedroom, so she can wake up every day and maybe she sees herself in my work. That's so much of what I appreciate about my practice and what I'm able to do. I am still figuring out how to answer this question, but I hope that provides some insight.

NIKOLE:

I appreciate your humility in answering that question, because I think so often we want to pretend that we have it all figured out when we don't, and this is complicated. I think when those of us who come from marginalized communities find success, it introduces new complications. I also appreciate your talking about the hierarchy in the art world. In a country that is built on a racial hierarchy, where it's harder for Black people even to be in a financial position to buy the art, but also to be in the kind of prominent position that galleries kind of want to have your name attached to the work, I think it does become exclusionary.

But what I do appreciate about you and also people like Bisa Butler is that there's a very intentional effort to ensure that Black collectors have a shot. I go into certain affluent, white people's houses

and their homes are filled with the work of Black artists, and while I'm like, yes, of course, you want that because there's a recognition of our humanity, and I hope a contemplation of our humanity that is necessary, you're also like, what does it mean that folks are collecting Black art, and not necessarily the people who are represented in the art and who are most connected to the art? I think that kind of sharing of knowledge is so important.

I get asked this question all the time: Who is your work for? But I always say, I think this should be two questions: Who is your work for, and who is your work to? And they may not necessarily be the same. So, I'd love for you to answer that however you wish.

GIO:
That is a very complex question. The separation of the to and the for—I'm definitely going to be thinking about this a lot. My work is a dedication to my parents. They have passed away now, but everything that I do, I think of it coming from them and it being a part of their legacy. It is for my grandmother, who's also passed away. I remember so much of her spirit being rooted in kindness and love, and I draw on that so much for my work.

I do it for people who, just like me, were not exposed to art throughout their lives, who don't think it's possible or feasible to do this work. And for the Black women in my life, who loved me and who supported me and lifted me up when I needed it the most—it's for them. And for Black women and girls who will see my work wherever it's shown and, perhaps, that will be the first time they see artwork that really reflects them in a way that is honest.

My work is a love letter to Black women and Black girls. That's primarily who I'm making this work for. It is also for me. I see it as a part of the process of healing from the traumas I've endured throughout my life. I do this work so that I know that it is possible. I know that that's odd to say, because I'm a person doing it, but it's still a reminder to me that it is possible to achieve the greatest things that I aspire to in spite of a system that is built so that I would not ever come close to achieving them. And I hope to do this work so that I can reach back to build a path and contribute to the journeys of those who come after.

Detail of *Pretty Pretty 7*, 2021

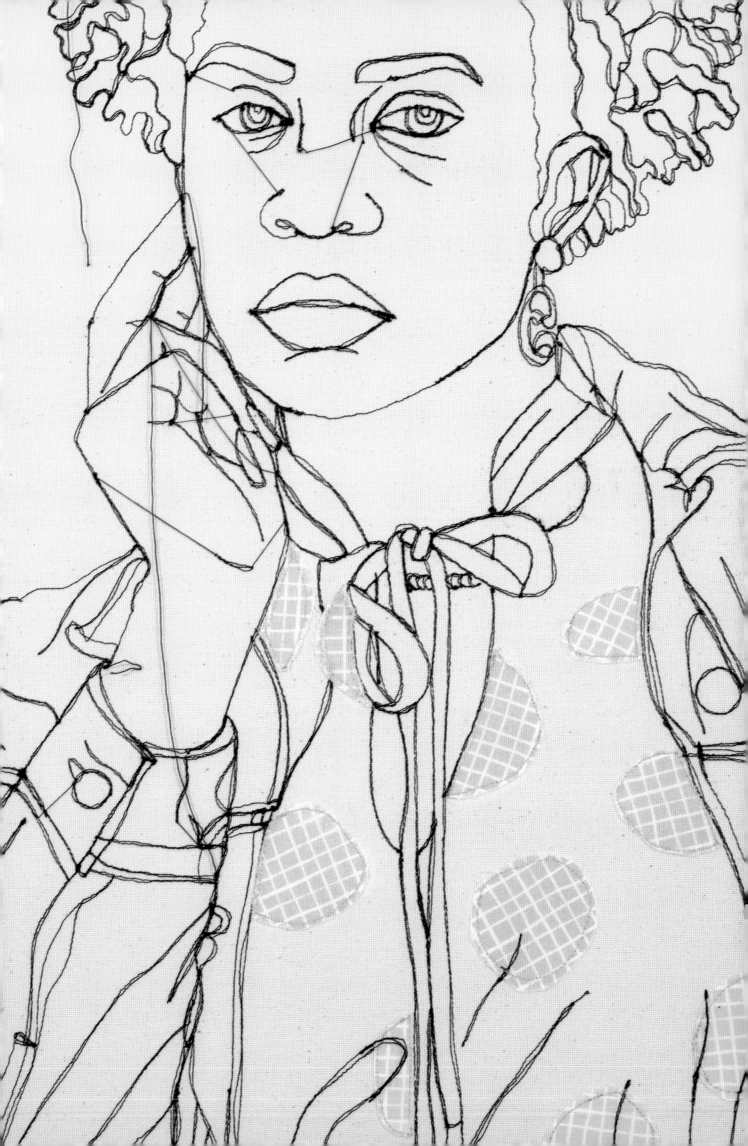

Coming Into Herself

Portraits and Relationships in the Work of Gio Swaby

KATHERINE PILL

Gio Swaby is a process-based artist in terms of both her mediums and the relationships she celebrates and nurtures in her works, which she deems love letters to Black women. Her practice is grounded in care and paying homage to friends and family, acknowledging that "there is an emotional labor that goes into Black sisterhood…sharing of experiences is important. We hold reflections of love up for one another."[1] Those reflections take myriad forms, rooted in individuality and self-presentation, and engage with the power dynamics that are inherent in acts of looking. Swaby considers her portraits a form of resistance to one-dimensional presentations of Black womanhood, ensuring a representation of the Black female figure that is defined through the lens of reciprocal love and caring.

Swaby's practice echoes that of artist Emma Amos (1937–2020), who famously stated that simply walking into her studio as a Black woman was a political act. In 1994 Amos completed a 48-part series of watercolor and acrylic portraits titled *The Gift* (fig. 1), made for her daughter, India, over the course of four years, and representing the women in her life who had become an invaluable system of support. In an interview with Amos, scholar and activist bell hooks (b. 1952), who sat for one of the portraits, noted what the series would represent to India: "She'll be surrounded by not only the representation of community but the concrete power both in the images of those women and in the act of your honoring those images."[2] The series is a testament to the crucial need for systems of support and the reciprocity of paying tribute. It shares a conceptual link to Swaby's work, as both are based upon specific women who are important to the artists—embodiments, in hooks's words, of "concrete power."

This power is seen most clearly in Swaby's photo shoots, which serve as a point of connection. Photography is foundational

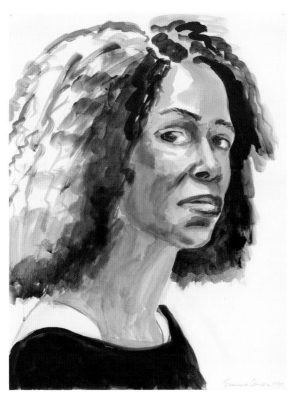

FIG. 1. Emma Amos, *Emma Amos* from *The Gift*, 1990. © Emma Amos; Courtesy of RYAN LEE Gallery, New York

(fig. 2). Showing the back is a vulnerable act for those practicing embroidery, as it makes visible the mistakes that can happen, as well as the stitching process itself: the rough order in which segments of the portrait are created, and the stopping points along the way. Swaby's intricately sewn portraits convey the details of the subjects' faces with spare but technically complicated lines, the inherent messiness of being represented in the trails of hanging threads and exposed knots so often hidden. She works against "the tyranny of perfectionism," as stated in Watt's essay in this volume detailing Swaby's free motion sewing process.

During a photo shoot, which typically involves the artist and one subject, Swaby looks for a moment when the subject "comes into herself," having reached the point of feeling comfortable in front of the camera.[5] Selecting that moment, Swaby says, is the one intuitive part of her diligent process: "It's a feeling I get. Being there in person and seeing it happen, the shift, while watching the

FIG. 2. Gio Swaby, *Another Side to Me Second Chapter 5* (detail), 2021, Thread and fabric sewn on canvas, 36 × 28 inches

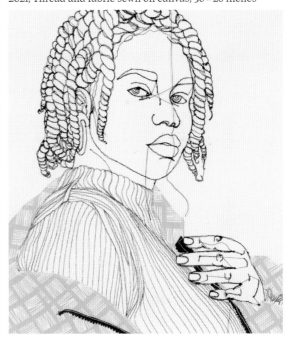

to Swaby's practice, although she uses varied mediums to reflect the subjects in her work, as detailed in Melinda Watt's essay on the artist's engagement with textile traditions. While working on early self-portraits (2014), Swaby recalls having "a moment of seeing myself in a different way, almost through different eyes. I wanted to include other women in that process. It was natural for me to start reaching out to the women who are closest to me in my life to take part in this experience that I felt was so intimate and personal."[3] Acknowledging through her own experience that "Black women can live within a paradox of hypervisibility and yet still not truly seen,"[4] Swaby's portraits are commanding, but nuanced in their representations of both strength and vulnerability. In the series *Another Side to Me* (begun 2020), for instance, Swaby for the first time exposed and embraced the back of a stitched portrait

photo being taken and then reflected in the reel—it's like going on a journey with someone. It happens at different points with different people, but it's almost always an easily identifiable point for me when I'm looking back at the shoot."[6] Swaby is collaborative throughout the portrait process. She asks subjects to wear "going out clothes" (defined in Swaby's series introduction) to the shoot, so that they feel confident and comfortable. She allows the subjects to find their own poses so that the personal body language of each is highlighted. Swaby also shares the works in progress with the subjects, and at times she has included their own clothing in the final portraits (the eyeglass frames in *Going Out Clothes 3*, for instance).

The *Pretty Pretty* series (begun 2020) is the result of evolution of *Another Side to Me*. In it, Swaby highlights specific items of clothing and accessories by including panels of fabric and colored threads, enlarging

FIG. 3. Amy Sherald, *Sometimes the king is a woman*, 2019, Oil on canvas, 54 × 43 × 2½ inches. © Amy Sherald. Courtesy the artist and Hauser & Wirth

the portraits to life-size. The first four works in the series are on unstretched canvas, while the later works are pulled taut on stretchers that suggest embroidery hoops. The thread work remains primary, but the fabric additions punctuate the parts of an outfit that either hold the most interest for the artist or have special significance for her or for the subject. A balance is struck so that the line is never overshadowed, but the subjects' stylistic choices, an integral part of self-definition, are emphasized.

On the cover of this publication is the self-portrait *My Hands Are Clean #4* (2017), featuring Swaby's calmly direct gaze, chin slightly upturned, her expression inscrutable. The portrait is not confrontational, but nor is it particularly inviting—this is a woman gazing upon herself, just being, thinking. Painter Amy Sherald (b. 1973), cited by Swaby as an influence, has recalled her interest in American realism, but Sherald noted that she "hadn't seen any work about just Black people being Black, captured in moments that were nothing special."[7] Although Sherald uses strangers—people for whom she has a particular feeling or to whom she gravitates when she sees them out and about—as subjects, her portraits are similar to Swaby's in the frontal gazes, the everyday-ness of the compositions and poses, even though Sherald freely reinterprets subjects' clothing (fig. 3). Both artists employ minimal backgrounds: Sherald creates a sense of otherworldliness through carefully built up layers of uniform color, while Swaby often leaves the canvas raw. The nondescript settings allow the figures to take center stage. In Swaby's *Pretty Pretty* series, focus is on the detailed lines that suggest folds and creases in the subjects' clothing, their personal accessories, and distinctive hairstyles.

Like Swaby, a number of contemporary artists working in Black portraiture eschew black and brown tones to denote

skin color, both to complicate the visual relationship between race and identity and to deepen an understanding of the vast range of skin tones. Sherald paints her subjects in grayscale, and painter Jordan Casteel (b. 1989), whose practice also begins with a photo shoot, used greens, blues, and reds in the lovingly rendered nudes of her *Visible Man* series (2013–14). Bisa Butler (b. 1973) is another oft-cited influence on Swaby, and her work employs massive quilted representations of figures drawn from historic, found, and family photographs. Butler, like Casteel, uses a range of colors, including blue and green, to depict skin color, so that "a person's complexion is not used as a descriptor."[8] Swaby typically relies on the line and raw canvas, or densely patterned fabric, to represent flesh. The first time she sourced a skin-tone fabric was for the *Love Letter* series (begun in 2018): the shimmery material suggests movement with its reflection of light, and a sense of elasticity (although in fact it is cotton with a metallic finish). The shimmer is reminiscent of the intimate, luminous figural paintings of Arcmanoro Niles (b. 1989), who builds his colors upon blue and orange backgrounds and eliminates all use of white, black, and brown. He has stated, "One of the beautiful things about people of color, for me, are the reds, the purples, and the golden tones that glow. I wanted to push that as far as I can, while still having it be recognizably a specific group of people."[9] Niles depicts hair in purple or hot pink, and he embeds glitter into many of his canvases. This gives the paintings—based on memories and family photographs—a magical quality despite their quotidian, often vulnerable, settings.

Perhaps the artist with whom Swaby shares most affinity in terms of concept is Mickalene Thomas (b. 1971). Thomas stated of her 2016 through 2017 exhibition, *Mentors, Muses, and Celebrities*, "The inspiration behind the show is mainly love. I was thinking of how, as a woman of color, I have developed to be the woman that I am and how I see myself in others. We look at each other in this sisterhood way and it defines who we are—our sense of confidence, our sense of worth."[10] Thomas brings a queer Black female point of view to sisterhood, family, and desire. She explicitly addresses beauty standards by embracing aesthetics from the Black Is Beautiful movement begun in the 1960s and by inserting the figures into poses and compositions from the white- and Euro-centric art historical canon. Thomas calls her subjects muses, a complicated term that has so often been used within a patriarchal framework.[11]

Like Swaby, Thomas emphasizes collaboration with the subjects and sees the photograph as integral to the work: "I think the photograph defines my practice. It provides a connection between all the works. There's something about a photograph that I can never get in a painting."[12] In both photography and painting, Thomas famously updates western canonical works, making reference to the Three Graces of Sandro Botticelli's (1445–1510) *Primavera* (c. 1480), for instance, or, as in *Le déjeuner sur l'herbe: les trois femmes noires* (2010), Edouard Manet's (1832–1883) 1863 painting of the same primary title. In Manet's version, a nude woman is seated with two clothed men, a woman in a gauzy white garment behind them. In Thomas's, the figure in the back has been removed, while the woman at left assumes a similar position, though she is clothed, and gazes slightly past the viewer, not directly at them. Thomas replaces the lounging men with two women in patterned dresses, with dazzling hair and makeup, who gaze directly toward the viewer. Together they emanate power, despite their languid and relaxed poses.

Swaby most often depicts subjects individually, but in *Gyalavantin'* (fig. 4) she has brought three figures together onto one panel. The poses are individualized, and there are no facial details, but it is clear

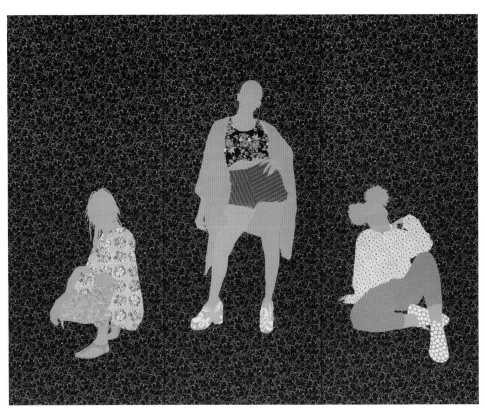

FIG. 4. Gio Swaby, *Gyalavantin'*, 2021, Thread and fabric sewn on canvas, 114 × 90 inches

that these women, together, are engaging the viewer directly. In *Le déjeuner*, Thomas incorporates a dizzying collage aesthetic, with a cacophony of patterns and jagged blocks of color. Swaby's patchwork is more contained, but *Gyalavantin'* allows for increased pattern play among the clothing of the three figures. In a number of Swaby's large portraits and in *Gyalavantin'*, as well as the *Love Letter* and *Pretty Pretty* series, figures are depicted crouching, with the top half of the canvases empty. These figures may not occupy that empty space, but they own it nonetheless—there's a suggestion that they could simply stand up and claim it.

Swaby's portraits, like Thomas's, engage with the power dynamics of looking, and being looked at. The writings of bell hooks have been foundational to Swaby's practice, particularly when it comes to considering the gaze as a form of resistance.

In "The Oppositional Gaze: Black Female Spectators," hooks details the power of working against flattened narratives of Black, female experience through critical spectatorship and details the power of looking between Black women. She describes a scene in the 1986 British film *The Passion of Remembrance* directed by Maureen Blackwood (b. 1960) and Isaac Julien (b. 1960), wherein two Black characters gaze at themselves and each other: "Dressing to go to a party, Louise and Maggie claim the 'gaze.' Looking at one another, staring in mirrors, they appear completely focused on their encounter with black femaleness. How they see themselves is most important, not how they will be stared at by others."[13] Like Thomas's work, Swaby's involves a sense of reciprocal viewing. She has stated, "There is specificity to the work. It asks us to consider multiple ways of being and seeing.

To challenge how we observe Black woman-hood and to hold room to have primary, more important dialogue about Black sisterhood, which is to ask how do we want to see ourselves and each other?"[14] Swaby's portraits are intimate in their process, grounded first and foremost in the relationship between artist and subject. The subjects are also, however, engaged in a public form of self-presentation, as they hold and return the gaze.

Women's studies scholar Beverly Guy-Sheftall has noted a link between Thomas's work and the early Black feminist theory of Afrofemcentrism, developed by scholar and artist Freida High W. Tesfagiorgis in 1984 as a means to speak specifically about artworks depicting Black women, made by Black women. Her defining essay, "Afrofemcentrism and Its Fruition in the Art of Elizabeth Catlett and Faith Ringgold," draws from theories associated with Black and feminist art to emphasize agency and primacy of the Black female figure, and to prioritize "women's realities over idealism."[15] These themes are also expressed in Swaby's work, which puts the female figure, and female friendships, at the forefront. It is imperative to Swaby that the word subject not be prefaced with a proprietary term: they are not "hers." Rather, the subjects, even in text, are presented as having their own agency.

hooks has written extensively on the need of Black audiences for counter-hegemonic images of Blackness that challenge both stereotypes and "the artistic imagination." She suggests that counter-hegemonic images "fulfill longings that are oftentimes unarticulated in words: the longing to look at blackness in ways that resist and go beyond the stereotype. Despite the tenacity of white supremacy as a world-view that overdetermines the production of images in this society, no power is absolute to the imagination."[16] Counter-hegemonic forms of Black figuration take myriad forms, and Swaby is part of a cadre of young artists

exploring nuanced representations of intimacy and love, as well as considerations of interiority, in a wide range of media. Amy Sherald has cited as an influence the work of writer Kevin Quashie, who details the risk of undervaluing quietness, which is "a metaphor for the full range of one's inner life—one's desire, ambitions, hungers, vulnerabilities, fears. The inner life is not apolitical or without social value, but neither is it determined entirely by publicness. In fact, the interior…is a stay against the dominance of the social world; it has its own sovereignty."[17]

Although Swaby's portraits are grounded in the act of self-presentation, the thread-based portraits particularly seem to ask viewers to consider the interiority of the subjects and the depth of their inner complexities. Swaby states, "I'm contributing to conversations of people, especially Black people, to create images of ourselves, represent ourselves in such a way that you can see a full person rather than something that might be a caricature or something one-dimensional."[18] The portraits grow out of conversations and connections with the subjects, as well as a desire to share that feeling of "coming into oneself" during a photo shoot.

Swaby is strategic in thinking about where her work is going to be viewed and acknowledges the fact that museums are in a moment of reckoning. She once stated, "I have five nieces, and when I'm making the work I'm thinking about them and want them to be able to see themselves represented in spaces [where] Black bodies are not necessarily always included or are historically excluded."[19] A number of artists have been creating images specifically for inclusion in institutions, as a means to counteract stereotypes and to broaden and complicate representations of Black identities. Kehinde Wiley (b. 1977), another influence cited by Swaby, famously inserts Black, street-cast figures into Western art historical traditions

on a monumental scale. He quite literally expands upon, and perhaps counteracts, the white- and Euro-centric canon. Sherald stated of her portraits, "The more museum spaces that I can fill up, the more change these paintings can project. They can be employed in many different ways, but hanging them on walls in accessible public spaces is essential. If you know African-American history, then you recognize the power of their presence."[20]

For Swaby, the viewing of her work functions almost as an activation, an extension of the relationship that is honored in the photo shoot. She states, "The work is never really done, doesn't come to an end. That comes from me shifting my perspective from these textile portraits being the most important part of my work or practice, to thinking about my work as making points of connection—the idea of visiting, the idea of gathering and coming together."[21]

Again, hooks's "concrete power" of human relationships is made immortal through portraiture. And perhaps the works themselves are never really done; the lines of thread that dangle from Swaby's *Pretty Pretty* canvases never quite stop moving, as the slightest breeze can make them quiver, changing the compositional structure of the work ever so slightly. Thus, like the subjects themselves, those thread-based portraits are perpetually in flux.

1 Nya Lewis, "Framing Black Sisterhood: An Interview with Gio Swaby," *Femme Art Review,* accessed June 2, 2021, https://femmeartreview.com/2021/06/01/framing-black-sisterhood-interview-with-gio-swaby-by-nya-lewis/.

2 bell hooks, "Straighten Up and Fly Right: Talking Art with Emma Amos," in *Art on My Mind: Visual Politics* (New York: New Press, 1995), 67.

3 Gio Swaby, in discussion with the author, July 21, 2021.

4 Gio Swaby, "Gio Swaby: She Used to Be Scared of Hair Comb," *Femme Art Review,* accessed May 24, 2021, https://femmeartreview.com/2020/06/05/gio-swaby-she-used-to-be-scared-of-hair-comb/.

5 Due to the restrictions of COVID, Swaby employed a Bahamian photographer—a friend—to conduct photo shoots for the later works in the *Pretty Pretty* and *Love Letter* series in the Bahamas while she participated via Zoom.

6 Gio Swaby, in discussion with the author, July 21, 2021.

7 Noor Brara, "Nine Black Artists and Cultural Leaders on Seeing and Being Seen," *T The New York Times Style Magazine,* June 2020, https://www.nytimes.com/2020/06/23/t-magazine/black-artists-white-gaze.html.

8 Michèle Wije, "Photography and Quiltmaking Transformed: A New Approach to Portraiture," in *Bisa Butler: Portraits,* ed. Erica Warren (Chicago: Art Institute of Chicago, 2020), 30.

9 Antwaun Sargent, "Orange Paint and Glitter Bring a Black Community to Life," *VICE,* May 8, 2017, https://www.vice.com/en/article/d7a75x/orange-paint-and-glitter-bring-a-black-community-to-life.

10 Antwaun Sargent, "Mickalene Thomas on Muses, Models, and Mentors," *Interview,* March 9, 2016, https://www.interviewmagazine.com/art/mickalene-thomas. Sargent has also written in depth on the concept of sisterhood in Thomas's work in "Sisterhood Is a Behaviour: Mickalene Thomas's Restaging of Womanhood" in *Mickalene Thomas: Femmes Noires,* ed. Andrea Andersson and Julie Crooks (Toronto: Art Gallery of Ontario, 2019), 64–72.

11 See Denise Murrell's study of the Black female figure being foundational to modern art, and Thomas's empowered muse, in *Posing Modernity: The Black Model from Manet and Matisse to Today* (New Haven: Yale University Press, 2018).

12 Lisa Melandri, "Mickalene Thomas on Beauty," in *Mickalene Thomas: Origin of the Universe,* ed. Lisa Melandri (Santa Monica: Santa Monica Museum of Art, 2012), 37.

13 bell hooks, "The Oppositional Gaze: Black Female Spectators," in *Black Looks: Race and Representation* (New York: Routledge, 2015), 130. See also Tina M. Campt, *A Black Gaze: Artists Changing How We See* (Cambridge: MIT Press, 2021). Campt expands on hooks's discourse and focuses on Black artists using lens- and performance-based mediums as a means to disrupt traditional modes of viewing, so that "looking at" becomes "a politics of *looking with, through, and alongside one another.* It is a gaze that requires effort and exertion," 8. Building upon the work of hooks, Campt states, "My idea of a Black gaze is one that disrupts the equation of a gaze with structures of domination by refusing to reduce its subjects to objects, and refusing to grant mastery or pleasure to a viewer at the expense of another... [A] Black gaze rejects traditional understandings of spectatorship by refusing to allow its subject to be consumed by its viewers," 38–39.

14 Lewis, "Framing Black Sisterhood."

15 Freida High W. Tesfagiorgis, "Afrofemcentrism and Its Fruition in the Art of Elizabeth Catlett and Faith Ringgold," in *The Expanding Discourse: Feminism and Art History,* ed. Norma Broude and Mary D. Garrard (New York: Routledge, 1992), 727. Art historian and curator Lowery Stokes Sims described links between Afrofemcentrism and the work of contemporary artists, including Lorna Simpson, Carrie Mae Weems, and Alison Saar, in "African American Women Artists: Into the Twenty-First Century," in *Bearing Witness: Contemporary Works by African American Artists* (Atlanta: Spelman College, 1996), 83.

16 hooks, "Facing Difference: The Black Female Body," in *Art on My Mind,* 96–97.

17 Kevin Quashie, *The Sovereignty of Quiet: Beyond Resistance in Black Culture* (New Brunswick: Rutgers University Press, 2012), 6.

18 Gio Swaby, in discussion with the author, July 21, 2021.

19 Pierre-Antoine Louis, "A Love Letter to Black Women," *The New York Times,* April 10, 2021, https://www.nytimes.com/2021/04/10/us/a-love-letter-to-black-women.html.

20 Tiffany Y. Ates, "How Amy Sherald's Revelatory Portraits Challenge Expectations," *Smithsonian Magazine,* December 2019, https://www.smithsonianmag.com/arts-culture/new-work-amy-sherald-focuses-ordinary-people-180973494/.

21 Gio Swaby, in discussion with the author, July 21, 2021.

Detail of *New Growth 2,* 2021

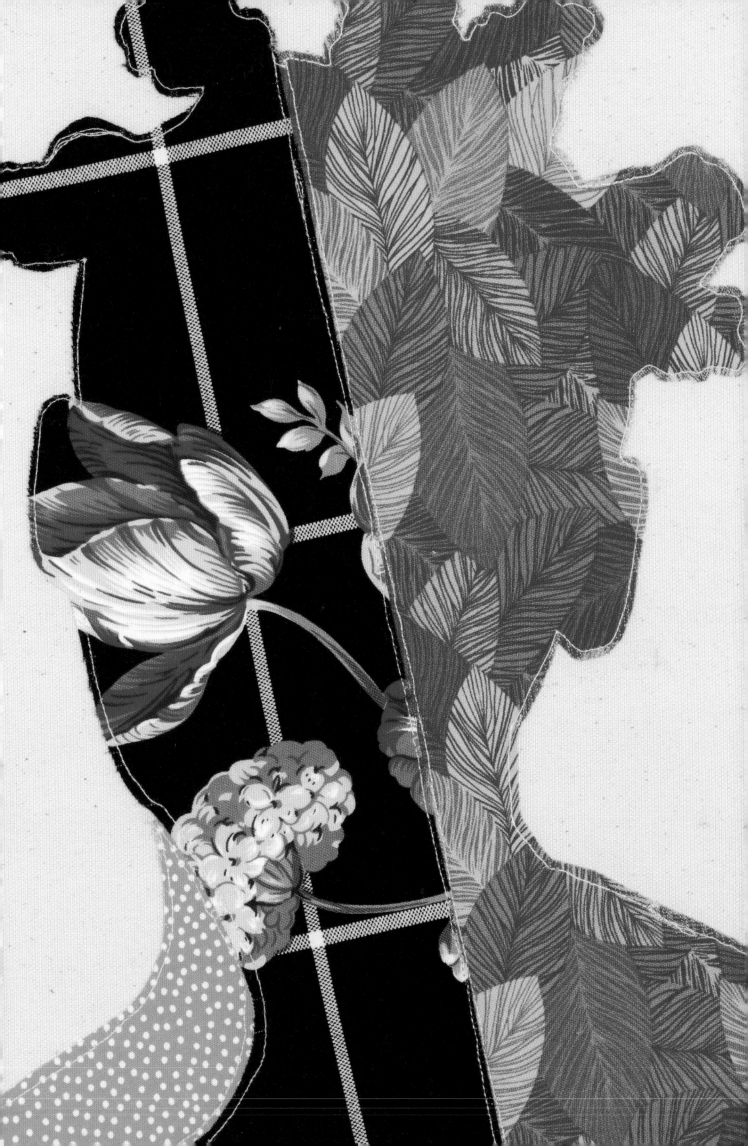

A Common Thread

Gio Swaby and the Art of Quilting

MELINDA WATT

Gio Swaby creates self-portraits and portraits of women using thread and cloth. These materials associated with domesticity, which she uses to portray herself and her close circle of friends, reflect her personal history. The traditional association of textile making—embroidery, quilting, dressmaking—with the domestic domain of women is deliberately referenced in Swaby's work. Swaby's mother was a seamstress, and in the time-honored tradition of passing needlework skills from mother to daughter she taught Gio to sew. Gio recalls working on projects with her mother, sewing doll clothes and Halloween costumes, and has said, "I connect textiles with an act of love."[1]

In addition to having a personal connection to fabrics and sewing, Swaby sees the textile medium as a point of entry for her audience. Nikole Hannah-Jones specifically calls out the evocation of female domestic labors of love in their interview. The use of quotidian materials is a choice that Swaby embraces in the name of offering accessibility, particularly to museum- and gallery-goers who historically have not seen themselves represented within the art establishment:

> That's such a foundational part of my practice, the idea that [my work] should be accessible, that people who may not have been exposed to art throughout their lives could still see my work and find those connections to it. [Using] textiles is part of the way that I do that. I am using material that is a part of almost everyone's daily experience, something that we are constantly coming into contact [with]. From sleeping on bedding, to waking up and getting dressed, textiles are so integrated into our lives. I feel [it] adds this approachability to the medium and removes some of those boundaries in accessing and connecting to the work.[2]

While at first glance Swaby's stitched portraits do not appear to have characteristics in common with traditional quiltmaking, several techniques used by quilters are adopted in her work. When Swaby was a student, she was mentored by quilter Jan Elliott at Popopstudios International Center for the Visual Arts, where Swaby had a residency in 2013.[3] It was Elliott who introduced Swaby to free motion quilting, using a specialized sewing machine that, unlike a conventional sewing machine, allows stitching in any direction. Swaby has transformed free motion stitching from a purely functional method of attaching layers of cloth to a form of embroidery akin to drawing. In her hands, it becomes lyrical and fluid, resulting in a singular form of line-making with thread on canvas. Repeated passes of stitching increase the density of the lines, so that they vary from delicate to heavy. This technique is the basis for the bust-length portraits in the *Another Side to Me* series begun in 2020 and subsequently the full-length *Pretty Pretty* portrait series (fig. 1.) Additionally, Swaby subtly features elements of machine sewing that are normally unseen. The "right" side of both the *Another Side to Me* and the *Pretty Pretty* portraits is actually the underside of the stitching, the side that is normally on the back or the interior of a sewn object, where differences in thread tension can also result in heavier marks. Her desire to blur the line between finished and unfinished is further emphasized by the presence of uncut threads that dangle from selected elements of the images. These loose threads give the viewer a sense of the delicacy of the materials and the intricacies of the portraits themselves. Swaby uses the loose threads and the inversion of front and back to signal her rejection of the tyranny of perfectionism.

Embroidery and quilting require very little in the way of specialized equipment—a needle and simple frame are all that are strictly necessary. Materials—thread and fabrics—can be as humble or as luxurious as the maker's economic status and artistic taste allow. Often, cloth in and of itself is not of great intrinsic or monetary value; its value lies primarily in its significance to the artist or quilt maker, by virtue of its connection to them, those portrayed, or the intended recipient of the sewn object. Cloth can act as a signifier of a moment, place, or time, a proxy for a person, and a catalyst for personal narrative.

In addition to free motion machine stitching, fabric appliqué is another technique based in quilting practice that Swaby

FIG. 1. Gio Swaby, *Pretty Pretty 2* (detail), 2020, Thread and fabric sewn on canvas, 83 × 36 inches, Collection of Drs. Annette and Anthony Brissett

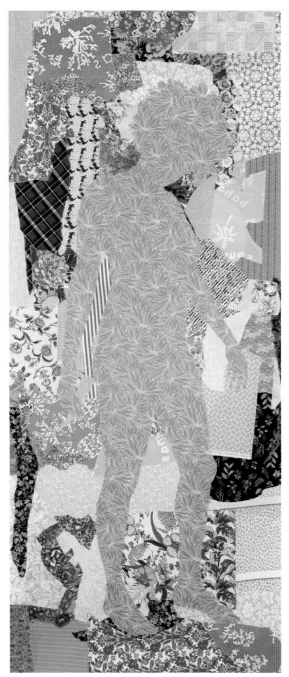

FIG. 2. Gio Swaby, *Differenter 2*, 2020, Thread and fabric sewn on canvas, 84 × 38 inches, Courtesy of the Artist and Claire Oliver Gallery, New York

uses in the *Going Out Clothes* and *Pretty Pretty* series to highlight the garments worn by each sitter. In the entries in the *Love Letter* and *New Growth* series, appliquéd patterned textiles appear as delicate silhouettes, delineating each sitter, her clothes, and her body. Like generations of quilters before her, Swaby often chooses these fabrics for their associations with individuals. She repurposes items of her own clothes for self-portraits, as well as requesting significant items from her sitters, as discussed in Katherine Pill's essay.

Swaby describes one of the ways textiles are chosen during the process: she and the subject decide on a fabric to include in their portrait. "Sometimes if I am photographing someone I might ask if they have a clothing object that they are willing to offer to me or to part with and I would use it in their portrait. It's just something about that aspect of having worn the clothing and having experienced parts of your life in this item that imbues it with a lot of personality. I think of it as having a new life through this artwork."[4] For textiles that have not come from the subject's own wardrobe, she speaks of "activating" fabrics, either new or recycled, by touching and handling them, and letting them reveal their character to her, creating new associations.

Swaby's Bahamian heritage is affectionately alluded to not only by the naming of her series using colloquial phrases like "Going out Clothes," in reference to one's best garments, but also by her use of textiles from Androsia Hand Made Batik. These fabrics are featured in the *Differenter* series (fig. 2), as well as the shoes that appear in *Love Letter 4*. *Differenter 2* contains a variety of printed patterns that Swaby employs to indicate her own diverse heritage, as well as that of the Bahamas as a nation: a green and black tartan, an English rose chintz, and an Indian-style floral chintz reference centuries of British colonial presence—a history of international commerce, exploitation,

and conflict that began in the late 1600s. In contrast, the orange and turquoise Androsia fabrics include fragments of palms and coral motifs, celebrating the natural wonders of this archipelago of 700 islands.

The batik cloth produced by Androsia became an unofficial national fabric of the Bahamas around the time that the country gained its independence from the United Kingdom in 1973. Androsia was founded on Andros Island just a few years earlier by Rosi Birch Lovedal, who with her then-husband ran a resort for divers called Small Hope Bay. Birch was driven by a desire to alleviate some of the economic challenges faced by the women she encountered on Andros.[5] The young company was further encouraged by the support of Dame Marguerite Pindling, wife of the first Black Bahamian prime minister, Sir Lynden Pindling. A native of Andros, Marguerite Pindling herself proudly wore the fabrics despite their sometimes unsophisticated lack of finish; Birch admits that there were flaws in the early production.[6] Swaby remembers her mother and aunts wearing Androsia fabrics for special occasions, and this cloth became synonymous with 1970s Caribbean chic. Images from the period attest to the fact that gender-neutral caftans of Androsia batiks were worn by guests and staff alike at the Small Hope Bay resort.[7]

In terms of materials, the use of painter's canvas as the foundation for Swaby's stitched portraits is both practical and symbolic. Canvas's advantages include its durability and the fact that it can be purchased in very large sizes. These features facilitate stitching and re-stitching, as well as the making of the life-sized portraits in the *Love Letter* and *Pretty Pretty* series. As discussed in Katherine Pill's essay, the spacious canvases give Swaby's subjects room for proudly taking up space. The use of canvas is also a nod to the creation of what is traditionally identified as fine art, i.e., painting on canvas, versus Swaby's textile-based work, which arguably blurs the line between art and craft. She uses canvas in both stretched and unstretched formats, but the material is always a prominent element of her compositions, thus continuing to play with the traditional use of canvas as merely the unseen foundation for painted work.

In her essay on the works of the quilt artists of Gee's Bend, Alabama, curator and quilt historian Amelia Peck comments on reactions to the quilts when they were "discovered" by white art historians in the 1970s: "Quilts are valid as authentic works of art only when they are defeminized by connecting them with a formal, predominantly masculine style of 'fine' art. Then, they can be removed from the uncomfortably domestic 'decorative' arena."[8] Peck espouses an appreciation of these quilts, and other forms of textile-based art, for their own aesthetic and cultural value, rather than as a response to other mediums.

Swaby generously names a number of Black female multidisciplinary artists whose work has been influential on her practice. If one considers the artists on Swaby's list who work in textiles—Faith Ringgold (b. 1930), Bisa Butler (b. 1973), and Billie Zangewa (b. 1973)—a multigenerational and multipronged narrative comes into focus. It recounts a shift away from consigning textile arts to the arena of craft, as simultaneously artists of color have grown increasingly prominent and techniques and subjects traditionally identified with femininity and domesticity have been destigmatized. Like Swaby, Ringgold, Butler, and Zangewa were introduced to sewing and textiles during childhood by their mothers. Swaby herself expands on that formative experience in her conversation with Nikole Hannah-Jones, describing the matriarchal structure of her family and her desire to honor her mother, sisters, aunts, and grandmother. These episodes in childhood education

manifest themselves in unique ways for each artist, but the common thread of shared experience cannot be discounted. It is evident in their art and in their statements about their work.

Quilting as a medium available to women artists and artists of color is central to the work of the preeminent Black quilt artist, art historian, and activist Carolyn Mazloomi (b. 1948). Writing in 1998, she assessed the role of quilts and textiles as a mode of artistic expression: "Certainly, the second wave women's movement resulted in an outpouring of quilts addressing issues of particular concern to women. Contemporary Black quilt makers have made important statements about the nature of womanhood and have expressed both the joys and difficulties of what it means to be Black and female. Their works express the poignancy of being devalued as human beings in a value-conscious society. Yet these artists also capture in their quilts the beauty, resilience, and versatility of Black women, qualities that remind us of who we are and 'how we got over.'"[9] Swaby's stitched and appliquéd portraits touch on themes of joy, beauty, and resilience in both her life and the subjects' lives.

In considering the narrative quilts of Faith Ringgold, author Jessica Hemmings reminds us that quilts function not only in the United States but in a variety of global cultures as vehicles for narrative. Hemmings writes, "Textiles, and perhaps quilts in particular, do deserve recognition not only as storytellers, but as storytellers with the potential to communicate alternative and unsanctioned versions of history."[10] This activation of large-scale textile works as monumental narrative works of Black American art is foregrounded in the Museum of Fine Arts, Boston's ambitious exhibition catalogue *Fabric of a Nation: American Quilt Stories*, in which the co-curators write, "For artists such as Faith Ringgold, Bisa Butler,

and Sanford Biggers, quilts have provided a platform through which to invigorate and shine light on Americans left out of history, especially African-Americans."[11] Swaby's *Love Letter 5* appeared in the final section of the exhibition, titled "Making a Difference." The curators highlight Swaby's embrace of Black joy and frame her work as an example of the output of a contemporary artist who is expanding the possibilities of quilt forms and textiles as art.[12]

Ringgold broke ground by bringing the narrative power of quilts and textiles to the attention of the art world, as well as forcing a reckoning with the traditional hierarchies of Western art. She is adamant about how the quilting medium affects the perception of her message. During the early 1970s, when she turned to fiber, she confronted categorizations and limitations that were imposed on her by the traditional art establishment as her fabric based images were categorized as craft, and they were described as "weavings, banners, textiles, fibers…I didn't like being accused of doing crafts. Being Black and a woman were enough. Did I need to be further eliminated on the grounds that I was doing crafts instead of 'fine art'?"[13]

Ringgold's study of Tibetan and Buddhist *thankas*—unstretched paintings framed by patterned silks—seems to have liberated her artistic practice from the Western expectation of what fine art looks like. She writes passionately about this revelation,

> Who said that art is oil painting stretched on canvas with art frames? I didn't say that. Nobody who ever looked like me said that, so why the hell am I doing it? So I just stopped; and now I do sewing and all kinds of things. Sewing has been traditionally what all women in all cultures have done. What's wrong with that? Politically speaking, I think some women would probably

say, "I don't want to be placed in the bag [of] women's art…sewing." Okay, that's your choice…I don't want to be placed in the bag where I think that all art is about making something that nobody can move. Making some big, monumental, monolithic thing which I can't even afford to do…Feminist art is soft art, lightweight art, sewing art. This is the contribution women have made that is uniquely theirs. [14]

In fact, Ringgold and two of her contemporaries in New York, Kay Brown (1930–2012) and Dindga McCannon (b. 1947), formed Where We At Black Women Artists, Inc. in the early 1970s, and this group of women became a kind of sisterhood, a community of women working in fiber and creating art that engaged with subjects of everyday Black life in America. Members could depend on each other for practical and moral support. In 1972, without support from the larger New York art establishment, Where We At staged its own exhibition in Harlem; as of 2021, Ringgold was the subject

FIG. 3. Bisa Butler, *The Safety Patrol* (detail), 2018, Cotton, wool and chiffon, appliquéed and quilted, 83 × 90 inches, The Art Institute of Chicago, Cavigga Family Trust Fund, 2019.785

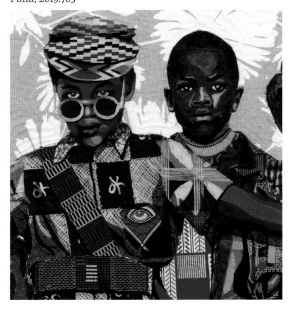

of a touring retrospective and, according to *The New York Times*, the world finally caught up with McCannon, as her first solo gallery exhibition opened in September of that year. [15]

Embracing textiles and their ability to speak to feminine, domestic, and personal issues, artist Bisa Butler emphatically proclaims to her hundreds of thousands of Instagram followers "there is no paint in this work" in reference to her portrait quilts. [16] The daughter of a seamstress, Butler employs a multitude of patterned textiles of the type commonly called African wax or Dutch wax in honor of her paternal Ghanaian heritage as well as that of the larger African diaspora. For example, in *The Safety Patrol*, the central figure's role as a protector is signaled by three fabrics: his sash is made of a kente cloth design, a cloth reserved for royalty, and his shirt is printed repeatedly with the letters "OK" and decorated with a protective eye. Butler employs these symbols to communicate that his future is bright and he and the other children will be safe. [17] (fig. 3)

Butler's work is actively changing the way visitors interact within an art museum context. [18] She attracts new audiences and evokes new ways of connecting with art on museum walls; viewers want to engage with the work and take countless images and selfies. Representations of Black Americans are functioning as a way to diversify the museum experience, as people of color see themselves over and over again in Butler's work. When asked to define the central message of her quilt portraits, Butler says she wants the viewer to see the "story of a Black family," a kind of photo album that contains "the moments people want you to see, " the celebrations of life's passages, the documentation of accomplishments. [19] Swaby's first solo New York gallery show elicited similar responses, especially from young Black women who positioned themselves next

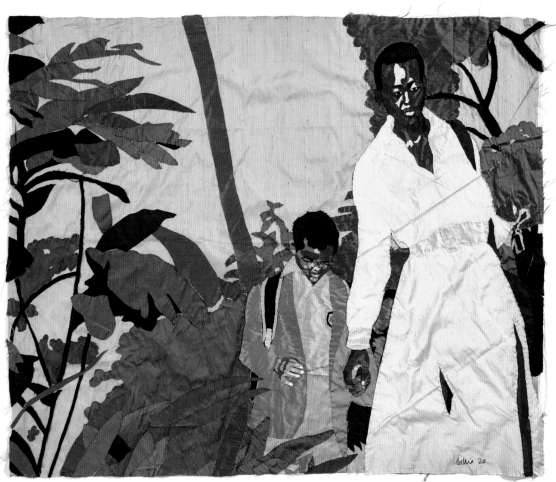

FIG. 4. Billie Zangewa, *Soldier of Love*, 2020, Hand-stitched silk collage, 53⅛ × 43⅜ inches, Courtesy of the artist and Lehmann Maupin, New York, Hong Kong, Seoul, and London

to her life size works, adopting the subjects' poses themselves.

"So much of my work is connected with this idea of domesticity," Swaby states. "This work connects with all of the unseen or under-appreciated labor that comes with womanhood. Working this way is how I honor that and show my gratitude."[20] Swaby's connection to domestic labor and her desire to foster appreciation for activities that she sees as central to female identity are echoed in the comments of Malawian-South African artist Billie Zangewa on her choice of textiles as a medium: "Fabric, this thing we all have a daily relationship with, is often dismissed by the world as mundane and unimportant, much like the daily, mundane work that women do to keep a home, a community, and a society going. I wanted to use this dismissed cultural thing to speak against patriarchy by creating powerful images about the importance of another dismissed thing, domesticity and the ordinary but important aspects of women's daily life and work in and around the home."[21] Zangewa has also chosen portraiture and self-portraiture as a method of communicating and honoring the beauty of everyday life. *Soldier of Love* (fig. 4) portrays Zangewa accompanying her young son to school. This picture of a daily activity also offers

a poignant take on maternal devotion that requires both strength and tenderness.

In assessing quilting's association with the feminine and the domestic, Amelia Peck writes about textile-making as possibly the sole acceptable creative outlet for women in history: "The rise of the female professional artist did not really begin in any meaningful way until the end of the nineteenth century, and the path toward being considered on equal terms with male artists is still somewhat rocky today. That path was even more difficult for women artists of color. However, there have always been artistic women.…Textiles, a material traditionally assigned to the female domain, were an accessible, uncontroversial place to create."[22]

Swaby's sitters are drawn from her family and friends—women she knows well, admires, and wants to celebrate. She strives to capture a moment of singular beauty, comfort, and ease, as Katherine Pill elucidates in her essay. A familiar pose is struck, the garments are particular, unique, recognizable, but only to those in the know—a favorite pair of boots, those beloved overalls, that cute bralette. These items of fashion symbolize the intimate artist/subject relationship.

As an artist, Gio Swaby demonstrates a firm command of material and technique gained through her formative years of practice, and this results in a fluidity and assurance of the embroidered line, outline, and silhouette. Thus, she can choose deliberately, convincingly, to reveal so-called imperfections like the dangling threads of *Pretty Pretty* and *Another Side to Me*. Her choice of materials, techniques, and the intimate circle of subjects result in a tightly focused and clear message of love and reverence for women in her life—their strengths, vulnerabilities, beauty, and individuality.

1 Sarah Cascone, "Meet Artist Gio Swaby, the 29-Year-Old Phenom Whose Sold-Out Debut Boasted Buyers Including Eight Museums (and Roxane Gay)," *Artnet*, June 4, 2021, https://news.artnet.com/art-world/gio-swaby-1973064.

2 Gio Swaby, interview with author, July 9, 2021.
3 "About," Popopstudios International Center for the Visual Arts, accessed July 17, 2021, http://www.popopstudios.com/about. "Popopstudios International Center for the Visual Arts is an independent art studio and gallery dedicated to the preservation and advancement of alternative Bahamian visual culture," located in Chippingham on New Providence.
4 Gio Swaby, interview with author, July 9, 2021.
5 "The Androsia Story," Androsia, https://www.androsia.com/the-androsia-story.html.
6 Rosi Birch, "Birch Family History," Small Hope Bay Lodge, http://smallhopebay.blogspot.com/2016/06/birch-family-history-by-rosi-birch.html.
7 Rosi Birch Lovdal, email to author, August 14, 2021
8 Amelia Peck, "Quilt/Art: Deconstructing the Gee's Bend Quilt Phenomenon," in *My Soul Has Grown Deep: Black Art from the American South* (New York: The Metropolitan Museum of Art, 2018), 63.
9 Carolyn Mazloomi, *Spirits of the Cloth: Contemporary African American Quilts* (New York: Clarkson Potter, 1998), 146.
10 Jessica Hemmings, "That's Not Your Story: Faith Ringgold Publishing on Cloth," *Parse* 11 (Summer 2020), accessed July 26, 2021, https://parsejournal.com/article/thats-not-your-story-faith-ringgold-publishing-on-cloth/.
11 Pamela A. Parmel, Jennifer M. Swope, Lauren D. Whitley, "The Story of American Quilts," in *Fabric of a Nation: American Quilt Stories* (Boston: MFA Publications, 2021), 14.
12 Jennifer Swope, phone conversation with author, July 30, 2021.
13 Faith Ringgold, *We Flew Over the Bridge: The Memoirs of Faith Ringgold* (Boston: Bulfinch Press, 1995), 198; quoted in Elissa Auther, *String, Felt, Thread: The Hierarchy of Art and Craft in American Art* (Minneapolis: University of Minnesota Press, 2010), 106. (Per Auther, this quote is from the mid-1970s.)
14 Hemmings, "That's Not Your Story," quoted in Auther, *String, Felt, Thread*, 105, and originally cited in "Conversations with Faith Ringgold on the Politics Behind Black Feminist Art," interview with Sandra Kaufman, May 10, 1975.
15 Jillian Steinhauer, "The World Catches Up with Dindga McCannon," *The New York Times,* September 10, 2021, https://www.nytimes.com/2021/09/10/arts/design/dindga-mccannon.html. Faith Ringgold retrospective was shown at the Serpentine Galleries in London (June 6–September 8, 2019), the Glenstone museum in Maryland (April 8–October 24, 2021), and the New Museum (February 17–June 5, 2022); McCannon's solo gallery show was at Fridman Gallery, 169 Bowery, New York, September 8–October 17, 2021.
16 For example, in a post dated July 14, 2021, refers to a work titled *Don't Tread on Me. God Damn, Let's Go!, The Harlem Hellfighters*; Butler began this practice in early 2019.
17 Bisa Butler, "The Safety Patrol," catalogue entry in *Bisa Butler: Portraits,* ed. Erica Warren (Chicago: The Art Institute of Chicago, 2020), 56, and gallery talk by Butler on July 22, 2021.
18 Bisa Butler's first museum exhibition, *Bisa Butler: Portraits,* was co-organized by the Art Institute of Chicago (November 16, 2020–September 6, 2021) and the Katonah Museum of Art (March 15–October 4, 2020). For further reading, see *Bisa Butler: Portraits,* ed. Erica Warren (Chicago: The Art Institute of Chicago, 2020).
19 Bisa Butler, interview by Sasha-Ann Simons, *Reset*, NPR, August 12, 2021.
20 Gio Swaby, interview with author, July 9, 2021.
21 Enuma Oroko, "The Textile Artist Who's Always Known How to Care for Herself," *New York,* June 26, 2020, https://www.thecut.com/2020/06/artist-profile-billie-zangewa.html.
22 Peck, "Quilt/Art," 69.

My Hands Are Clean

Don't touch my hair. Solange wrote a song about it, Emma Dabiri wrote a book about it, and Black women everywhere have long expressed our ire over this particular violation of personal space. I don't care if your hands are clean, even if you just washed them while singing the "Happy Birthday" song twice through. No, I don't care if you ask nicely, because what you are really asking is that I sacrifice my comfort to satisfy your curiosity. It is not an innocent request. Do not touch my hair. Because, even if I allowed it (which I will not), you don't know how. You are not qualified. You will certainly disturb the magical forces that hold my fro or my braids or my flat twists in all their glory. Caring for my hair is an act of love, initiated and mediated by touch. Do not disrupt, disrespect, or dishonor this sacred space.

Detail of *My Hands Are Clean 1*, 2017

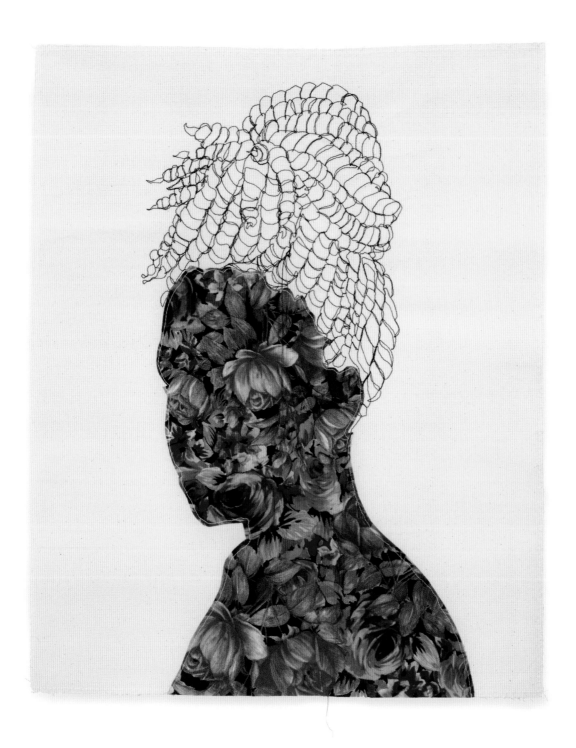

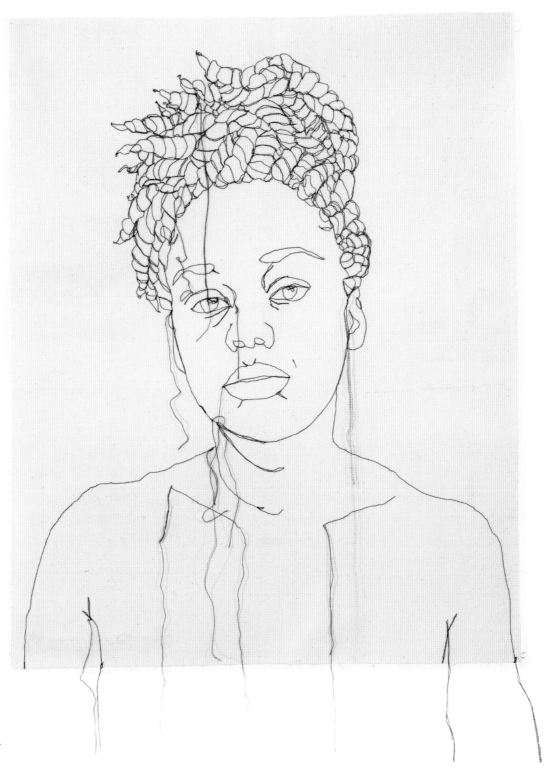

My Hands Are Clean 1, 2017
Thread and fabric sewn
on canvas
20 × 16 inches
Collection of Claire Oliver
& Ian Rubinstein

My Hands Are Clean 3, 2017
Thread and fabric sewn
on canvas
20 × 16 inches
Quattlebaum/McCaughey
Art Collection

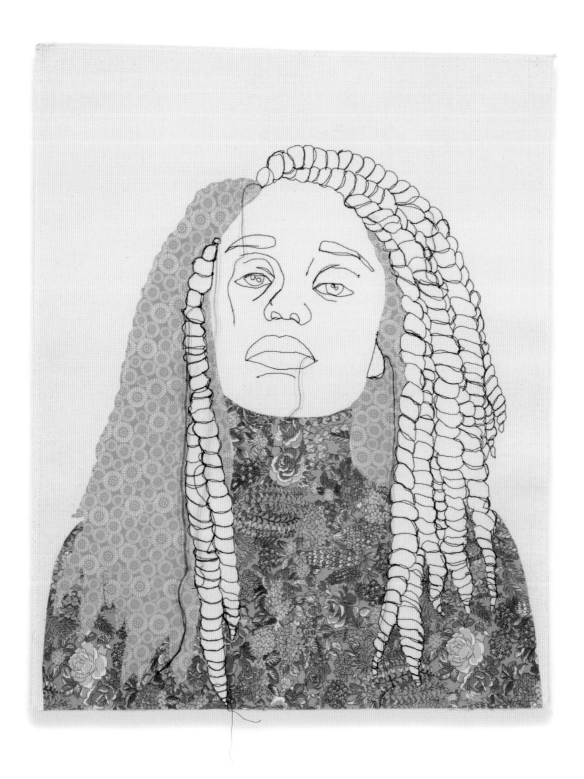

My Hands Are Clean 4, 2017
Thread and fabric sewn
on canvas
20 × 16 inches
Collection of Claire Oliver
& Ian Rubinstein

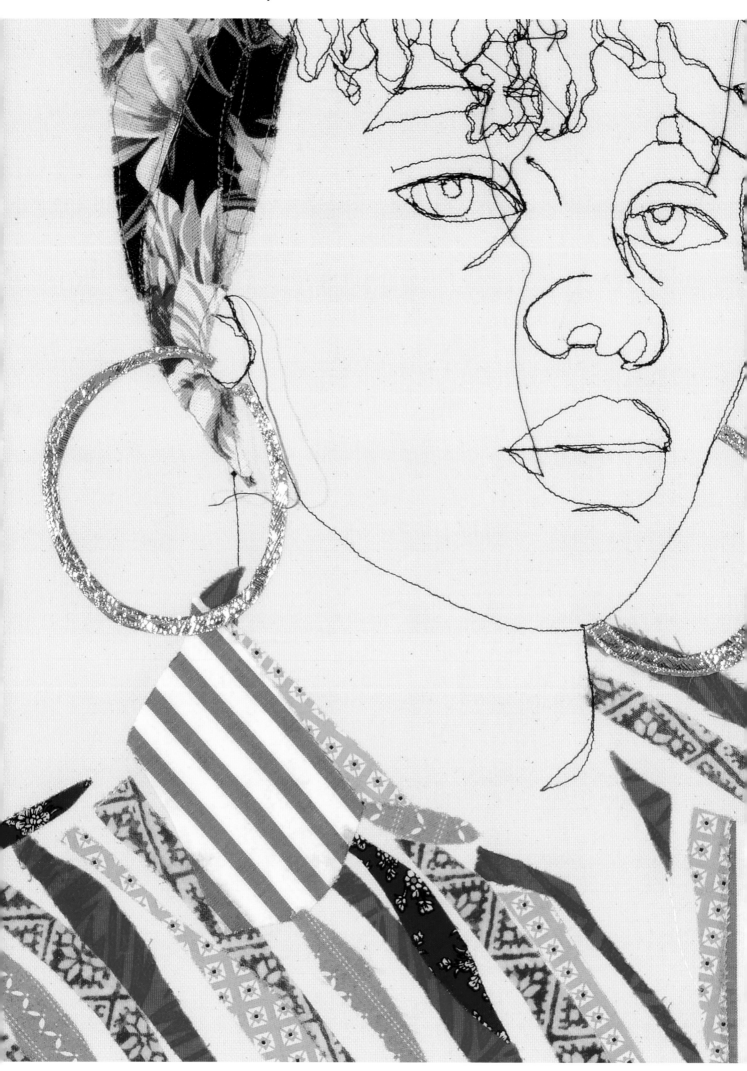

Going Out Clothes

In the Bahamas, your wardrobe is separated into three main categories: yard clothes, church clothes, and going out clothes. If you are like me, you were raised with a certain reverence for the latter. It was strictly forbidden to wear your going out clothes around the house or for more casual activities. So, it always felt like a momentous occasion when your mummy would let you wear your good jeans and a dressy top. This is especially true if you had the opportunity to put together your own outfit. My mother rarely let me have this responsibility because it would often end with me dressed in a glittery pink swimsuit with jeans and white patent leather heels. Though I am much less precise in how I choose to wear my clothing now, I still feel a particular satisfaction in putting together a 🔥 outfit. *Going Out Clothes* encompasses that joy and self-fulfillment through a presentation that is regular but regal.

Detail of *Going Out Clothes 1*, 2020

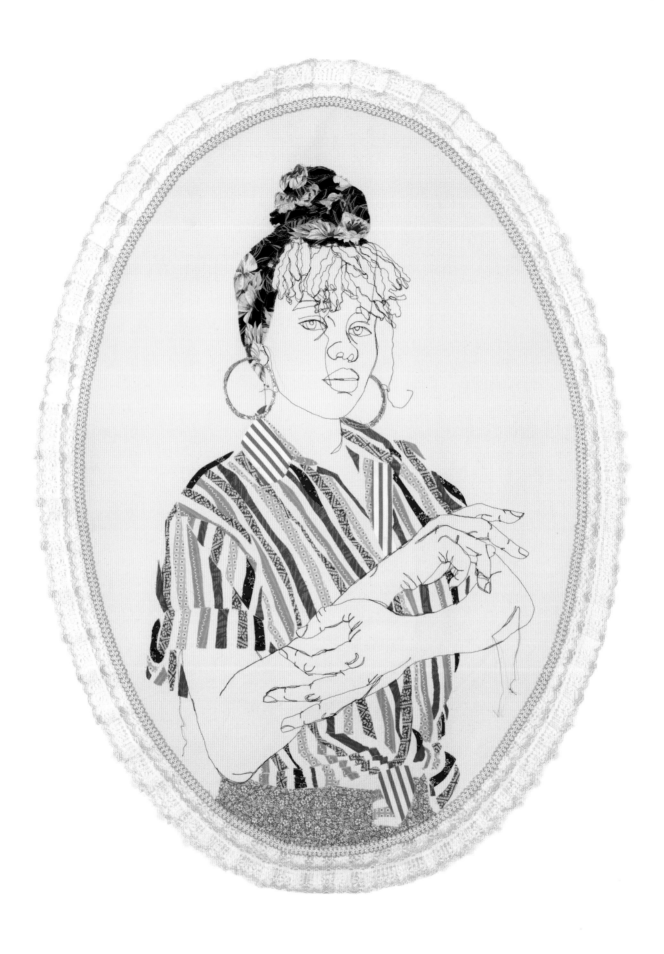

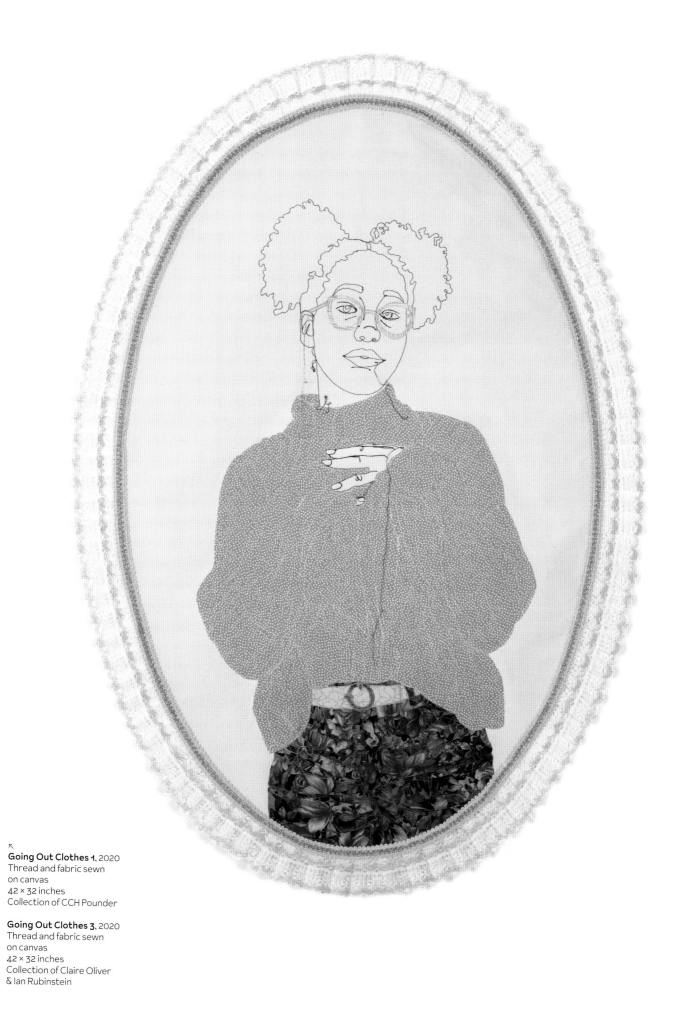

Going Out Clothes 1, 2020
Thread and fabric sewn
on canvas
42 × 32 inches
Collection of CCH Pounder

Going Out Clothes 3, 2020
Thread and fabric sewn
on canvas
42 × 32 inches
Collection of Claire Oliver
& Ian Rubinstein

Love Letter

To the women in my life who have loved me unconditionally and supported me always, these works are in dedication to you. To my mother and grandmother no longer here in the flesh, you will always carry on in my heart and through my work. I am deeply honored to contribute to a movement of healing that has been cultivated through the immense and unwavering care of Black women globally. This work is how I express my gratitude for the networks of knowledge and support that we have created and maintained for one another. It is how I celebrate a cyclical journey of unlearning and relearning how to better love myself and those around me. I hope that when Black women and girls see my work, they see parts of themselves reflected with reverence, utmost care, and love. My practice is reinforced by these beautiful moments of reciprocity. I create this work in celebration of us. Always and forever.

Detail of *Love Letter 3*, 2021

Gio Swaby

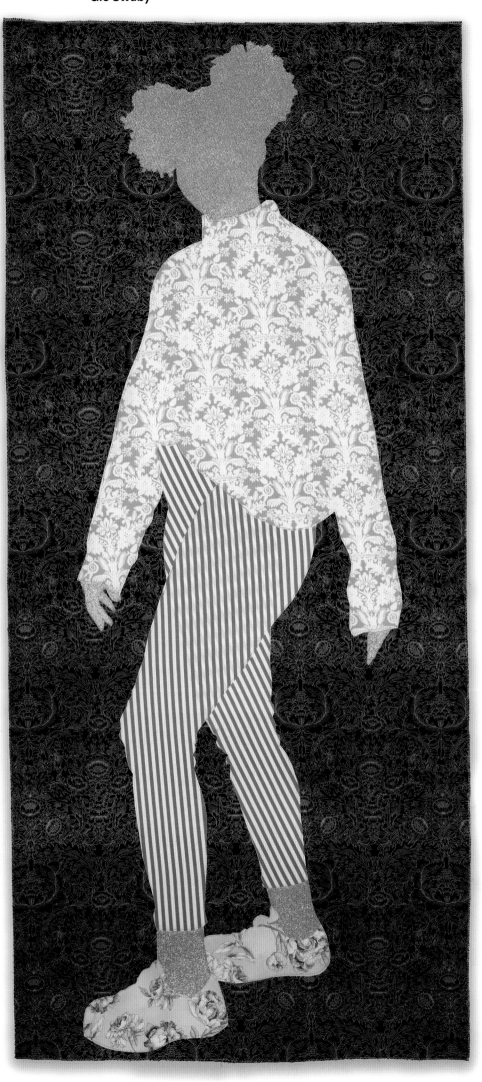

Love Letter 1, 2018
Thread and fabric sewn
on canvas
68 × 31 inches
Collection of Roxane Gay
and Debbie Millman

→
Love Letter 3, 2021
Thread and fabric sewn
on canvas
84 × 38 inches
Collection of Scott &
Cissy Wolfe

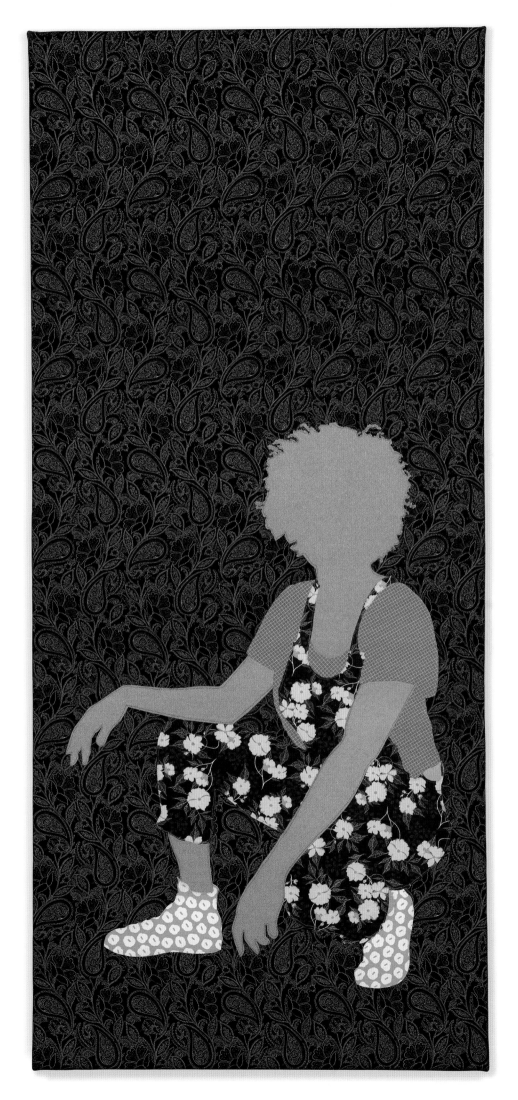

49

Gio Swaby

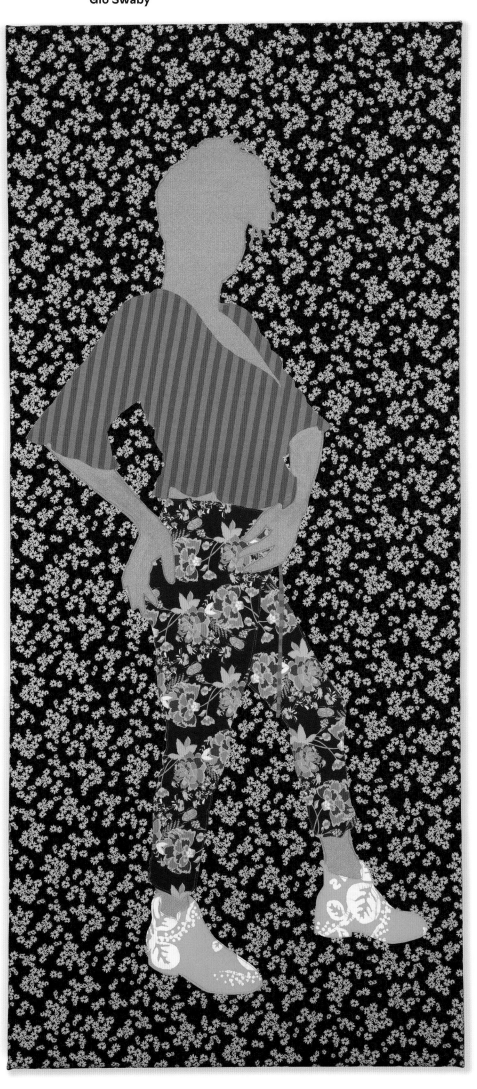

Love Letter 4, 2021
Thread and fabric sewn
on canvas
84 × 38 inches
Collection of
J. Sanford Miller &
Ella Qing Hou

→
Love Letter 5, 2021
Thread and fabric sewn
on canvas
84 × 38 inches
Collection of Museum
of Fine Arts, Boston, The
Heritage Fund for a
Diverse Collection, 2021.447

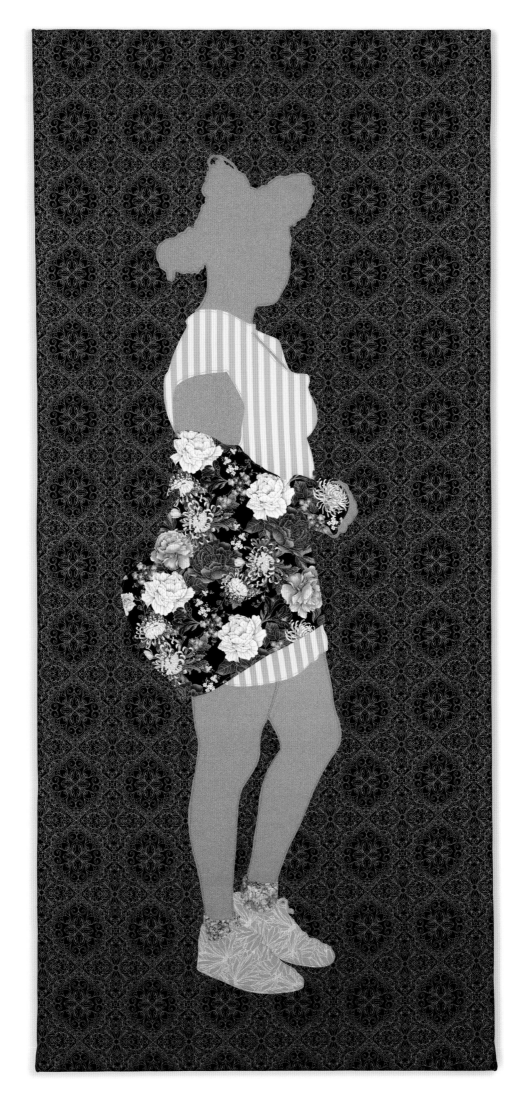

51

Gio Swaby

Love Letter 6, 2021
Thread and fabric sewn
on canvas
84 × 38 inches
Collection of Lisa &
Etienne Boillot

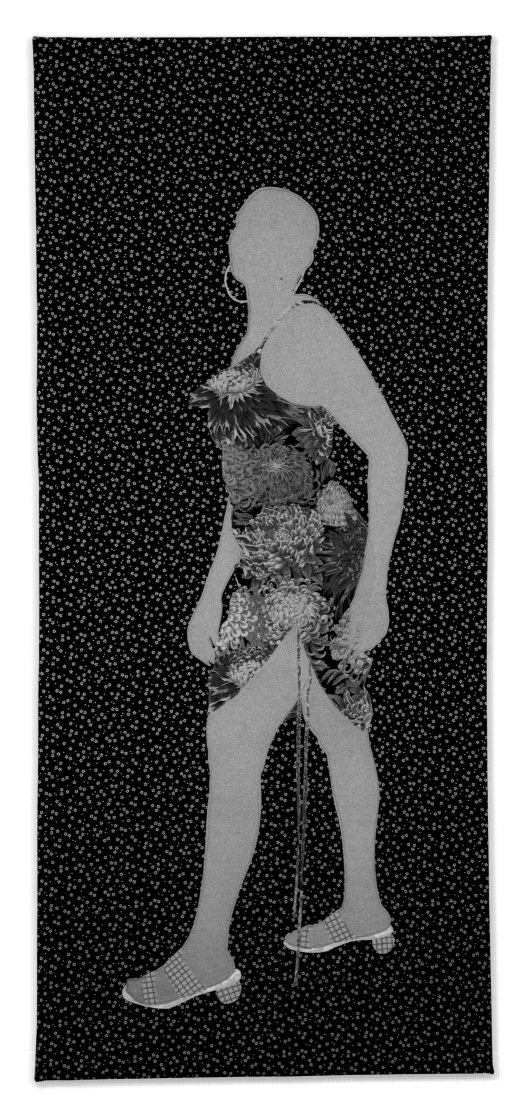

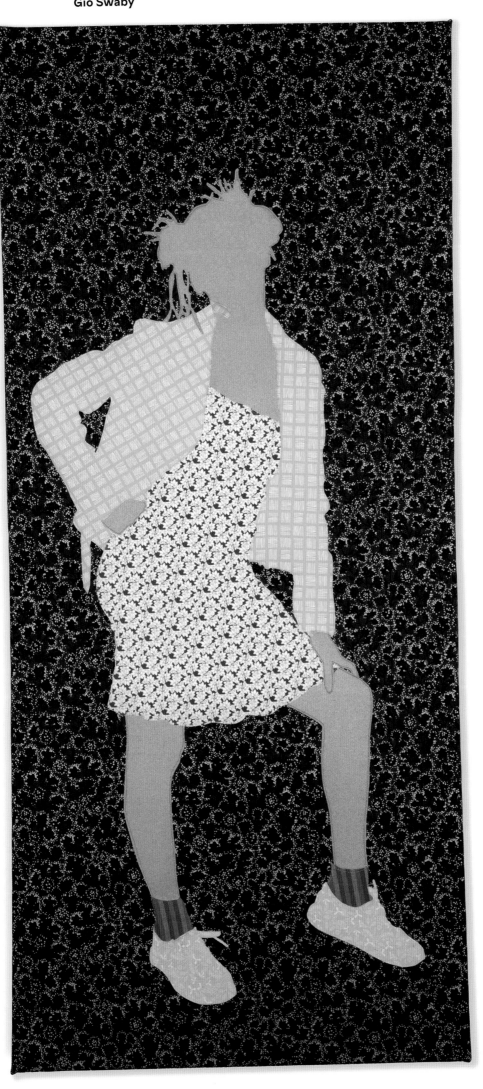

Love Letter 7, 2021
Thread and fabric sewn
on canvas
84 × 38 inches
Collection of Hill Harper

→
Love Letter 8, 2021
Thread and fabric sewn
on canvas
84 × 38 inches
Courtesy of the Artist
and Claire Oliver Gallery,
New York

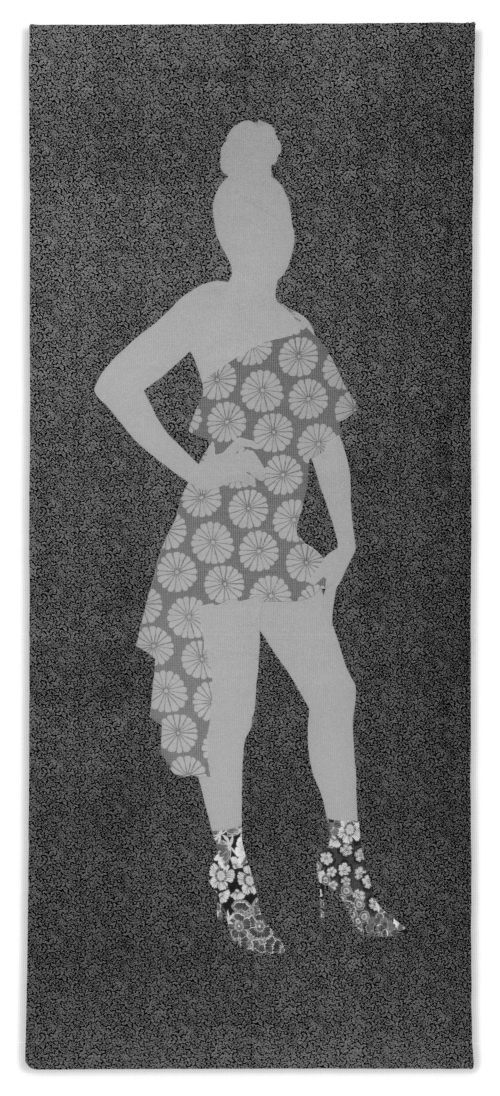

55

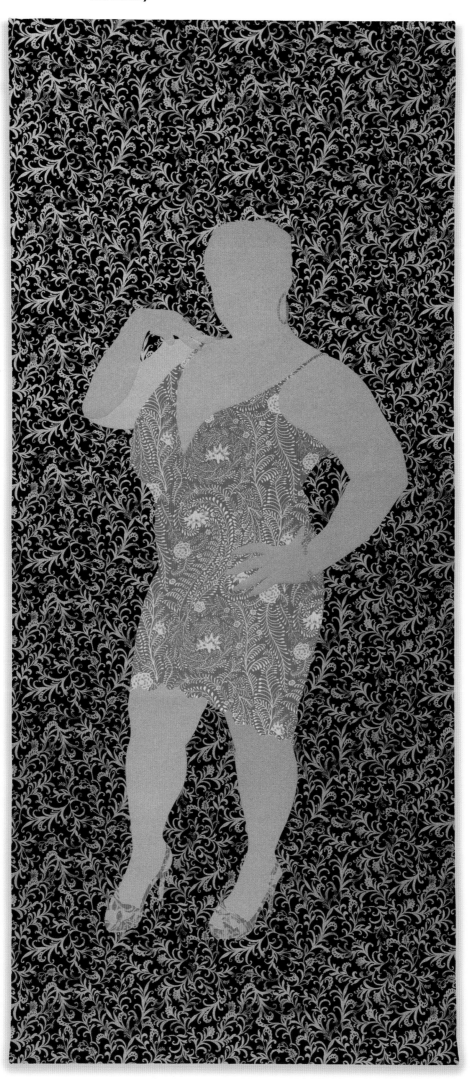

Love Letter 10, 2021
Thread and fabric sewn
on canvas
84 × 38 inches
Courtesy of the Artist
and Claire Oliver Gallery,
New York

→
Love Letter 9, 2021
Thread and fabric sewn
on canvas
84 × 38 inches
Courtesy of the Artist
and Claire Oliver Gallery,
New York

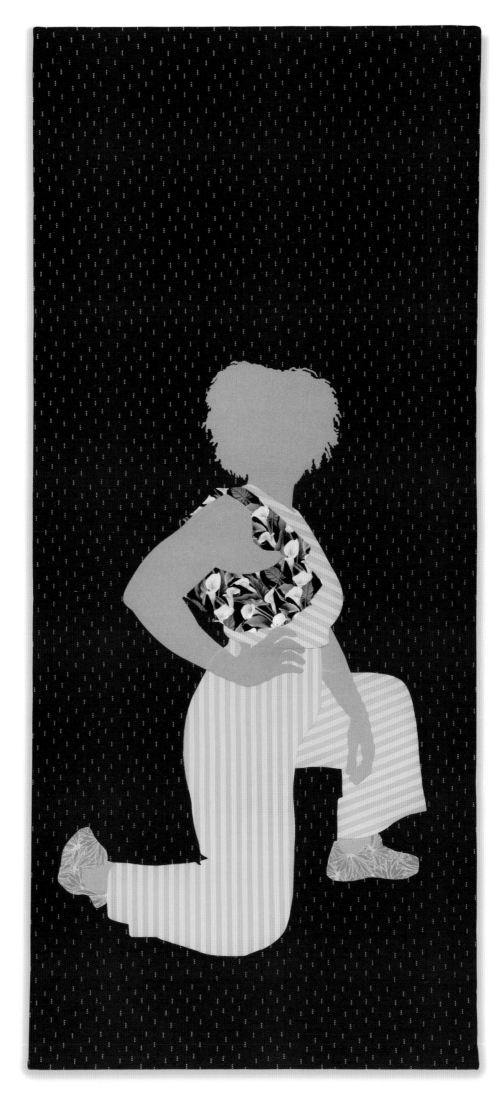

57

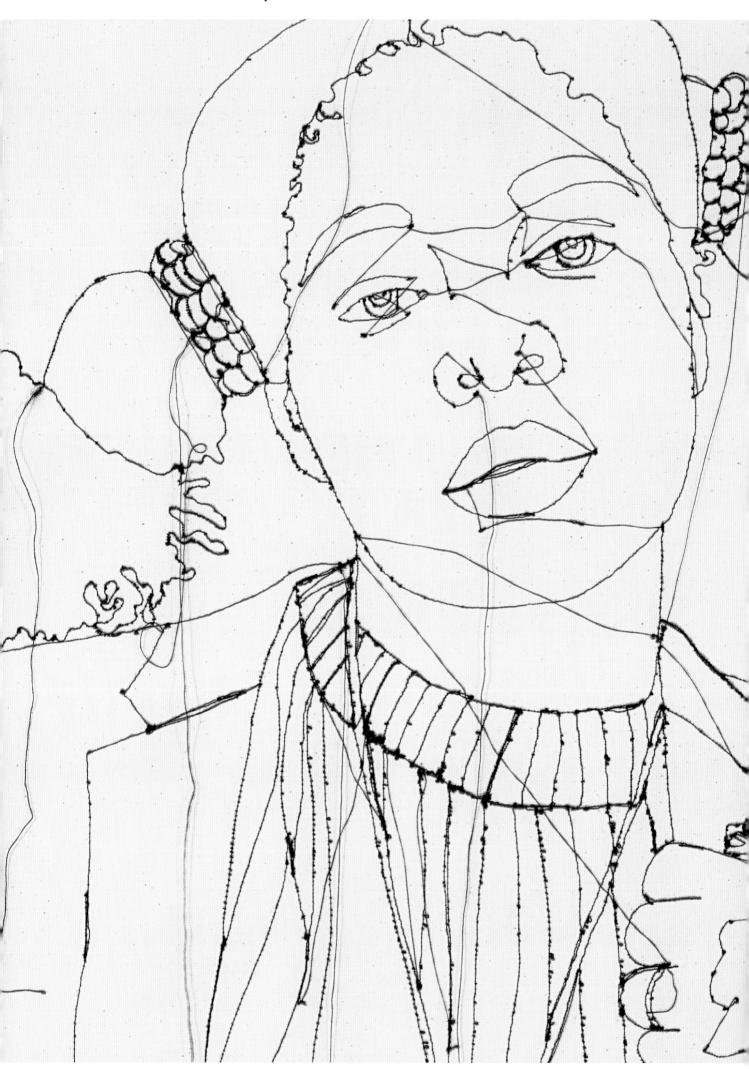

Another Side to Me

Another Side to Me was my first exploration of displaying the underside of a stitched rendering. As textile-based makers, this is the part of our work that we tend to conceal. In this series, the stitching process is laid bare, revealing the tangles, irregularities, and thread tails. It offers an opportunity to retrace the path of creation and builds a map of this journey. I've always found a kind of beauty in these "flaws." This work reflects so much of what it means to me to be human—fallible and imperfect. There is certainly a vulnerability in uncovering so much, but it exists in tandem with the strength to make such an offering. This work recognizes multilayered ways of being and resists a singular and simplified perception of Blackness and womanhood.

Detail of *Another Side to Me 2*, 2020

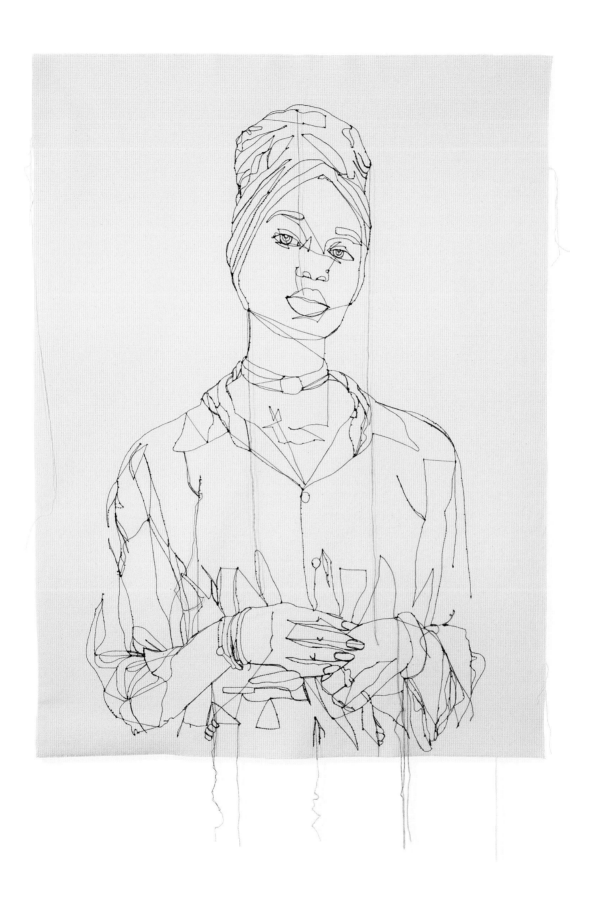

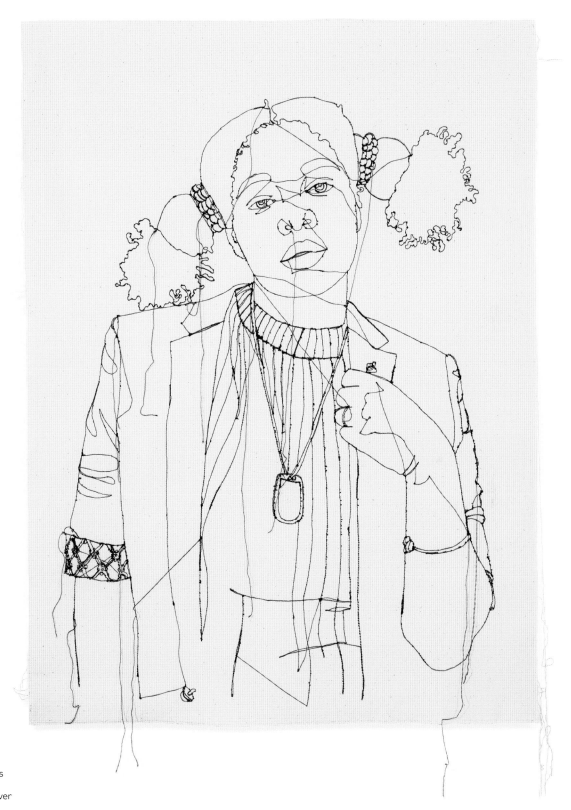

Another Side to
Me 1, 2020
Thread sewn on canvas
36 × 24 inches
Collection of Claire Oliver
& Ian Rubinstein

Another Side to
Me 2, 2020
Thread sewn on canvas
36 × 24 inches
Collection of Claire Oliver
& Ian Rubinstein

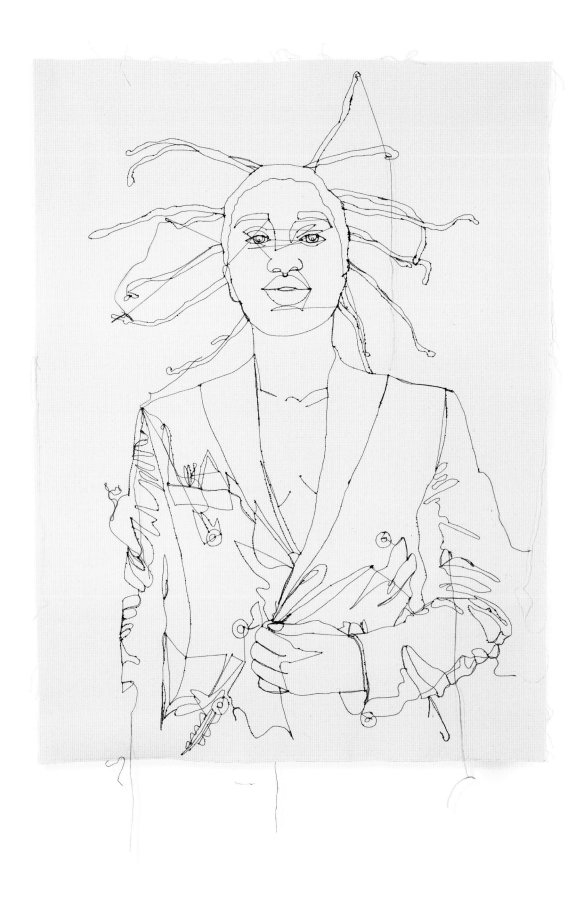

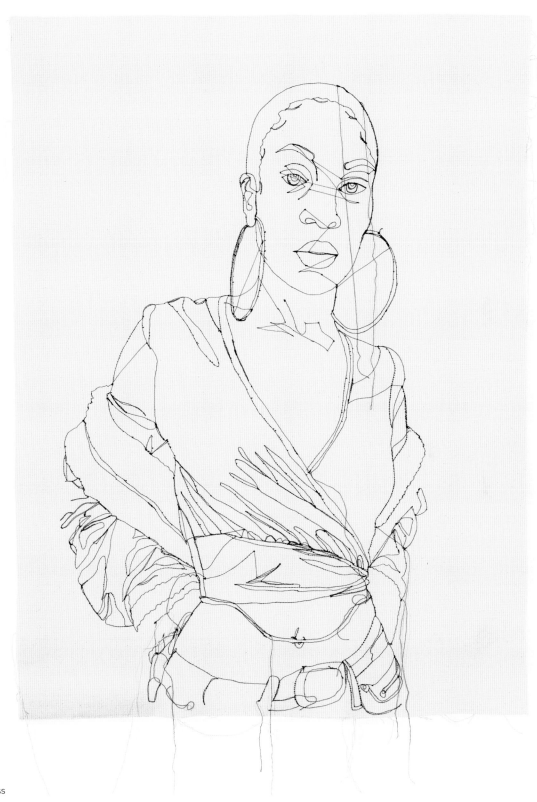

↖
**Another Side to
Me 3**, 2020
Thread sewn on canvas
36 × 24 inches
Collection of Yolonda Ross

**Another Side to
Me 4**, 2020
Thread sewn on canvas
36 × 24 inches
Collection of
Jason Reynolds

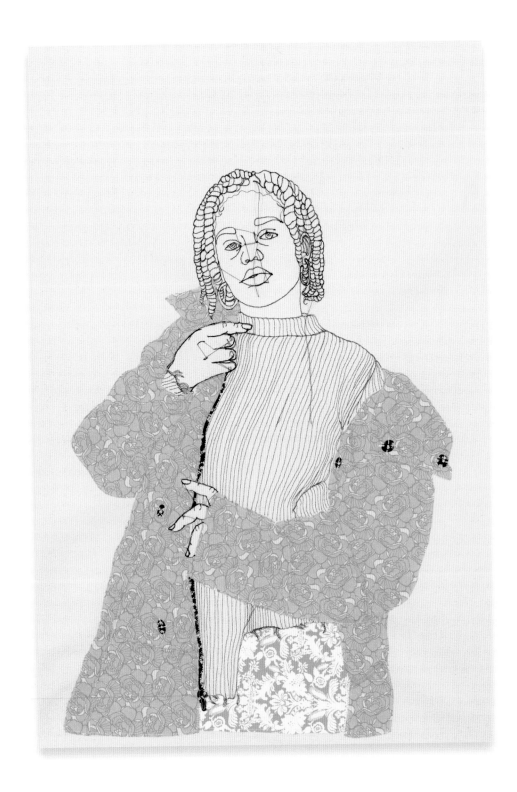

**Another Side to Me
Second Chapter 1**, 2021
Thread and fabric sewn
on canvas
36 × 28 inches
Courtesy of the Artist
and Claire Oliver Gallery,
New York

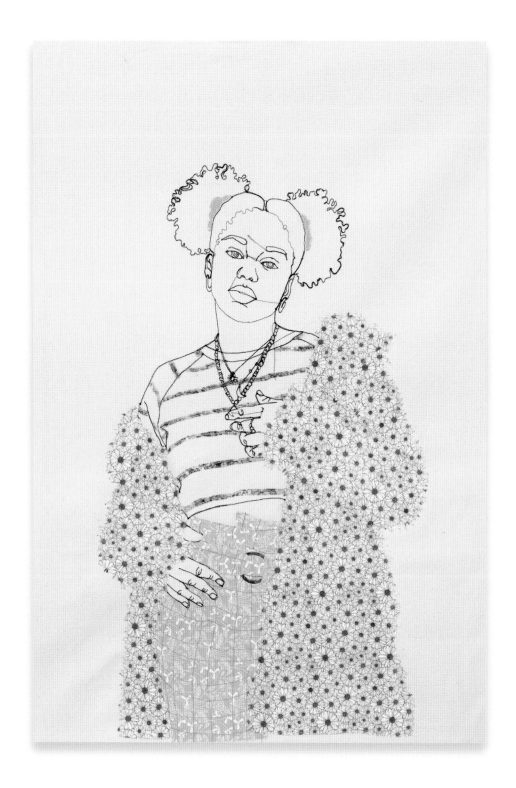

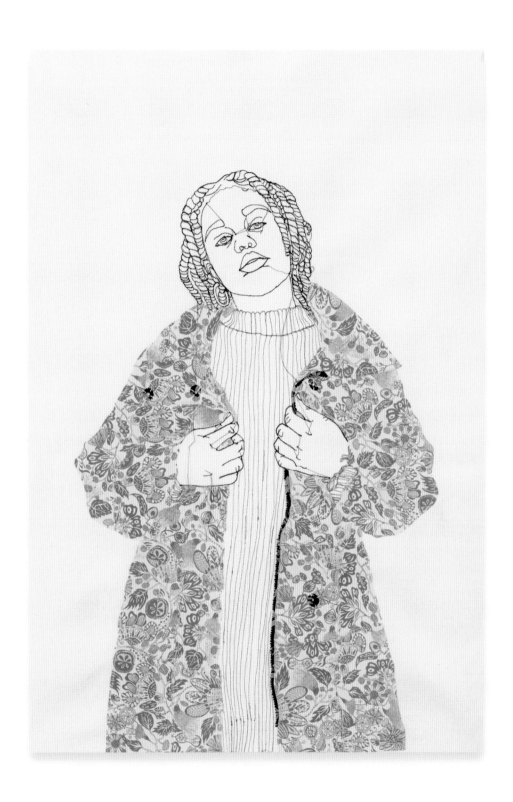

↖
Another Side to Me
Second Chapter 3, 2021
Thread and fabric sewn
on canvas
36 × 28 inches
Private Collection, Israel

Another Side to Me
Second Chapter 4, 2021
Thread and fabric sewn
on canvas
36 × 28 inches
Private Collection

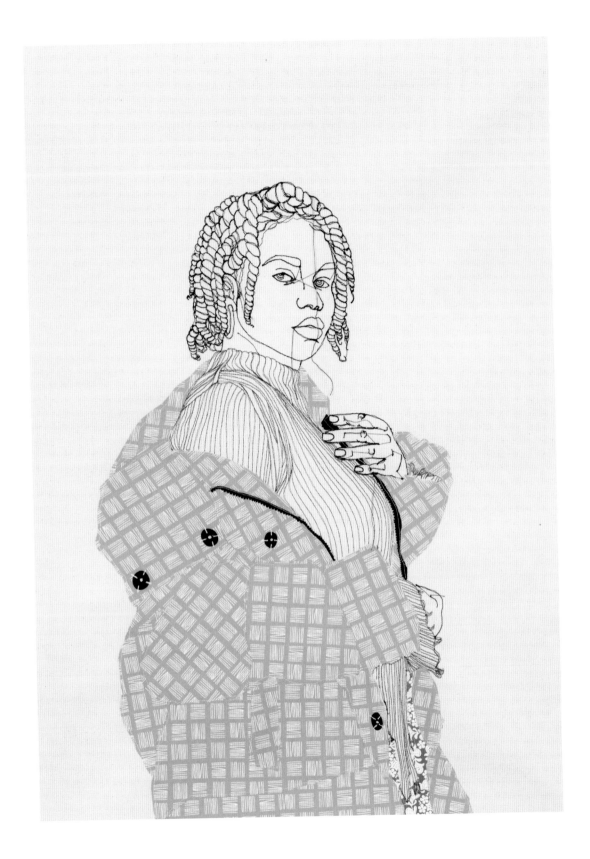

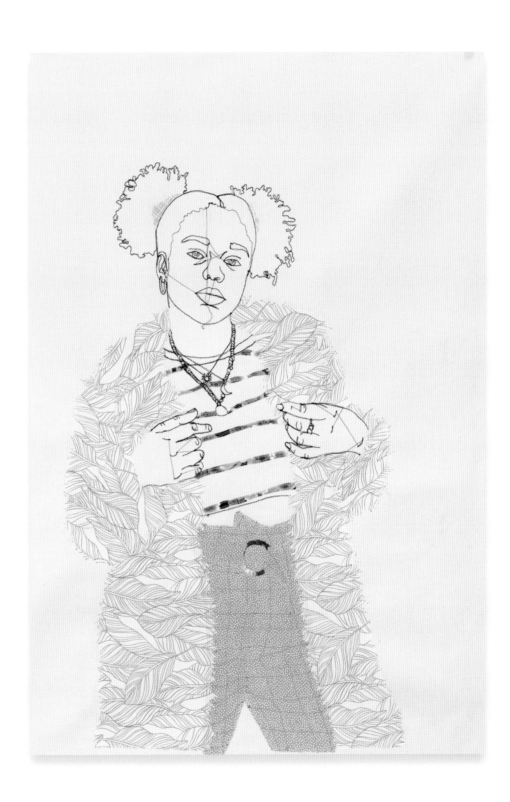

↖
**Another Side to Me
Second Chapter 5**, 2021
Thread and fabric sewn
on canvas
36 × 28 inches
Private Collection

**Another Side to Me
Second Chapter 6**, 2021
Thread and fabric sewn
on canvas
36 × 28 inches
Courtesy of the Artist
and Claire Oliver Gallery,
New York

Pretty Pretty

I want you to know that I see you. I see you in the full glory of your existence, apart from the flattened narrative systematically imposed upon us. I see you, both soft and strong, vulnerable and powerful. I see you, bright and beautiful, perfectly imperfect, nuanced and complex. I want you to have the space to be just who you are, unapologetically and without explanation. I want us to thrive, to rest, to be joyful, to love and be loved without limitations. I open this space for you, free of expectation and with room to grow. Your very existence is proof of your capacity for healing. I celebrate your journey and honor your perseverance. I also imagine a future that does not always call upon us to access such parts of ourselves. Together, let us exhale and release all notions that we are not good enough. We are worthy of it all.

Detail of *Pretty Pretty 6*, 2021

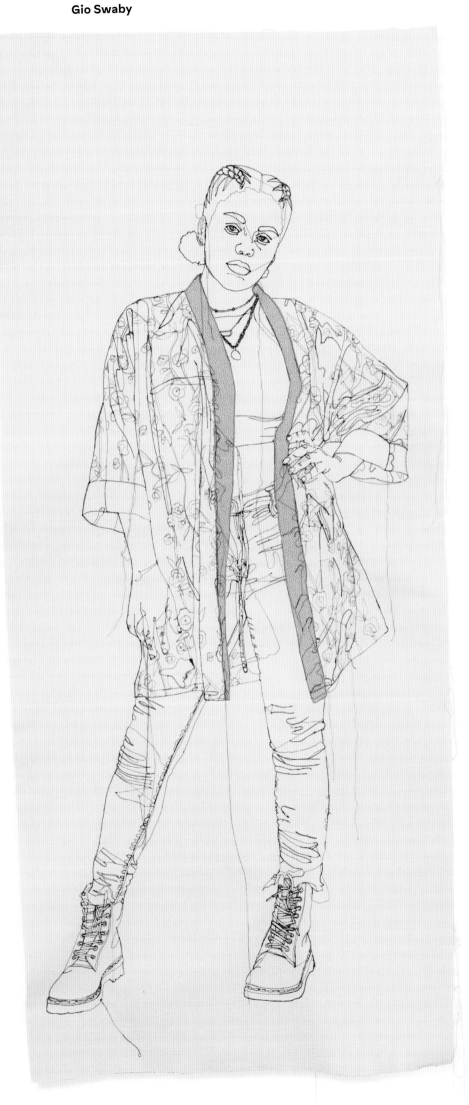

Pretty Pretty 1, 2020
Thread and fabric sewn
on canvas
83 × 36 inches
Collection of Bill &
Christy Gautreaux,
Kansas City, MO

→
Pretty Pretty 2, 2020
Thread and fabric sewn
on canvas
83 × 36 inches
Collection of Drs. Annette
and Anthony Brissett

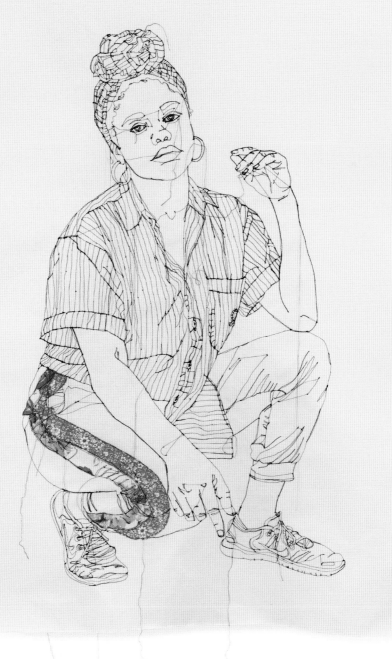

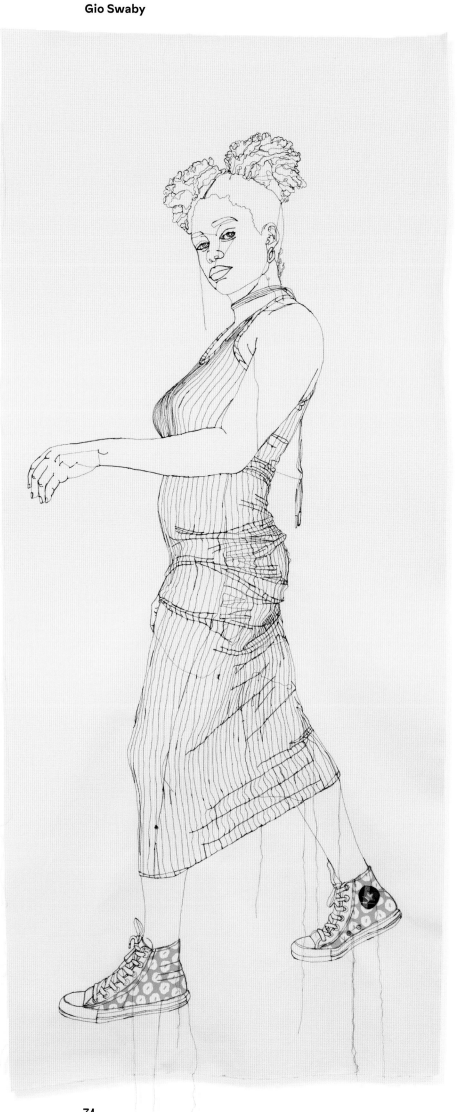

Pretty Pretty 3, 2020
Thread and fabric sewn
on canvas
83 × 36 inches
Collection of the
Minneapolis Institute of
Art, Gift of funds from
Mary and Bob Mersky

→
Pretty Pretty 4, 2020
Thread and fabric sewn
on canvas
83 × 36 inches
Collection of Susan
Chapman-Hughes and
Christopher Hughes

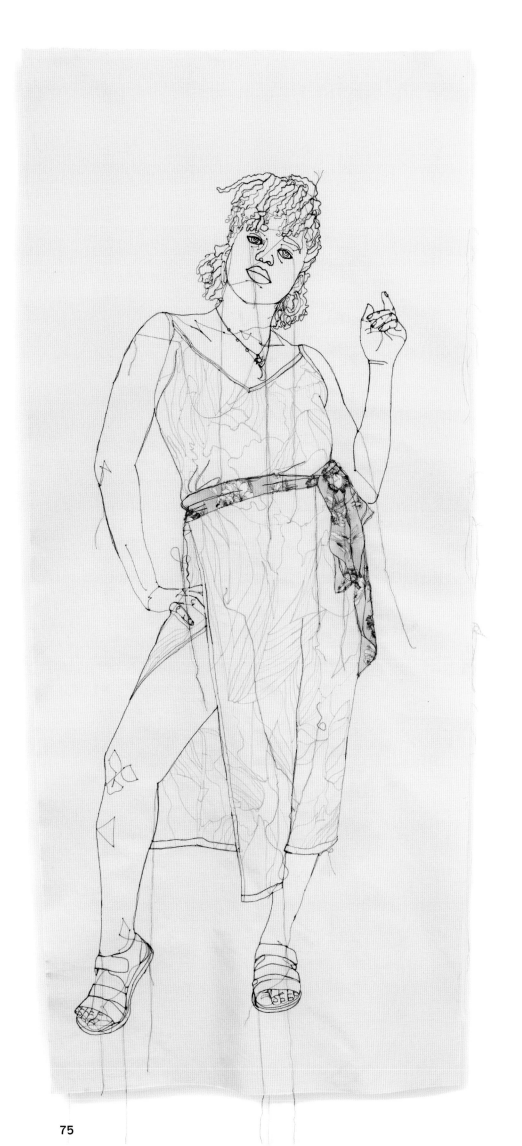

Gio Swaby

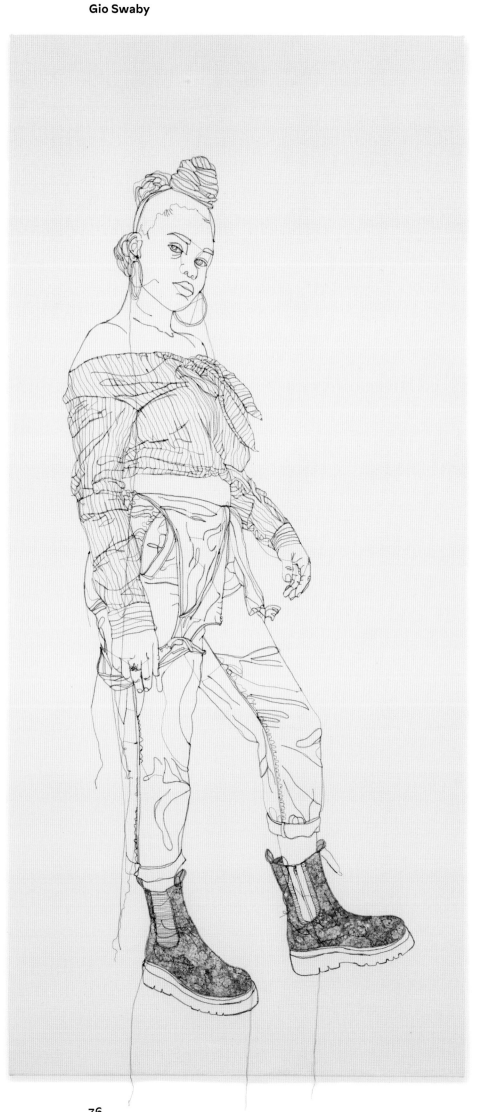

Pretty Pretty 5, 2021
Thread and fabric sewn
on canvas
83 × 36 inches
Collection of Claire Oliver
& Ian Rubinstein

→
Pretty Pretty 6, 2021
Thread and fabric sewn
on canvas
83 × 36 inches
Collection of the Frederick R.
Weisman Art Museum at
the University of Minnesota,
Minneapolis, Purchase
with funds given by Mary
and Bob Mersky, 2021.12

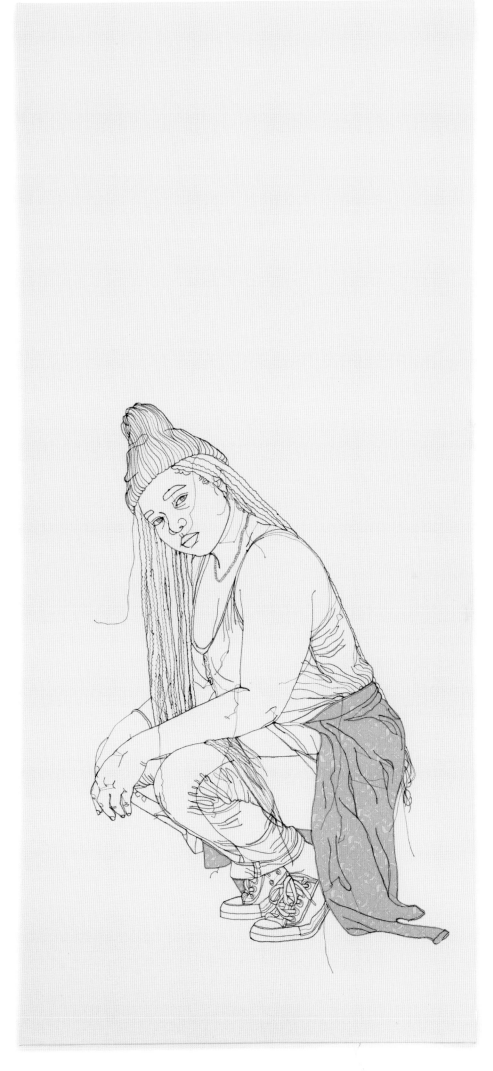

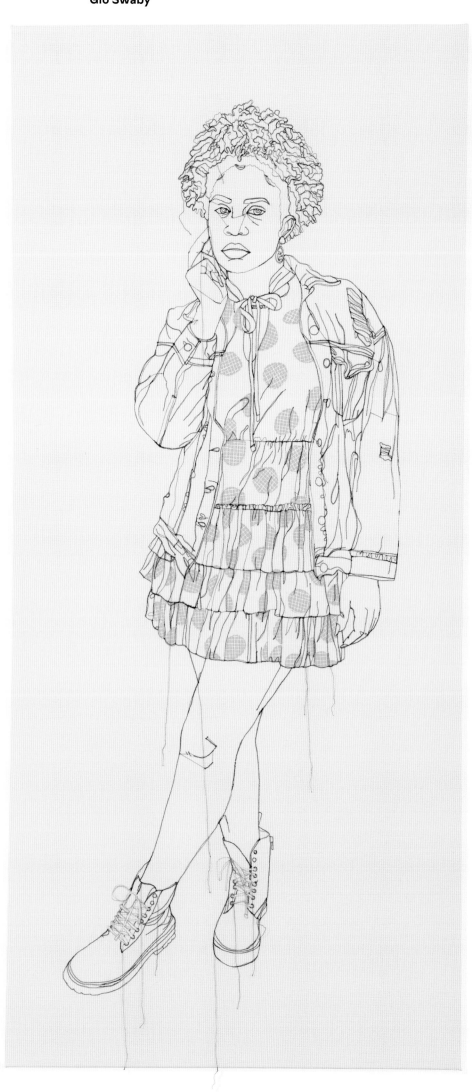

Pretty Pretty 7, 2021
Thread and fabric sewn
on canvas
83 × 36 inches
Collection of D'Rita &
Robbie Robinson

→
Pretty Pretty 8, 2021
Thread and fabric sewn
on canvas
83 × 36 inches
Collection of Museum of
Fine Arts, St. Petersburg,
Museum purchase in
honor of James G. Sweeny,
2021.2

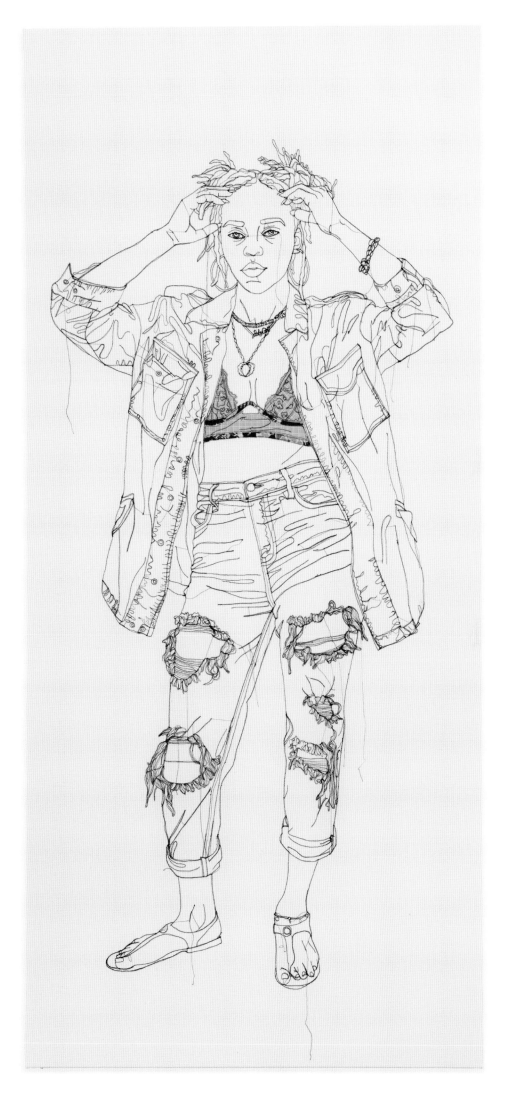

79

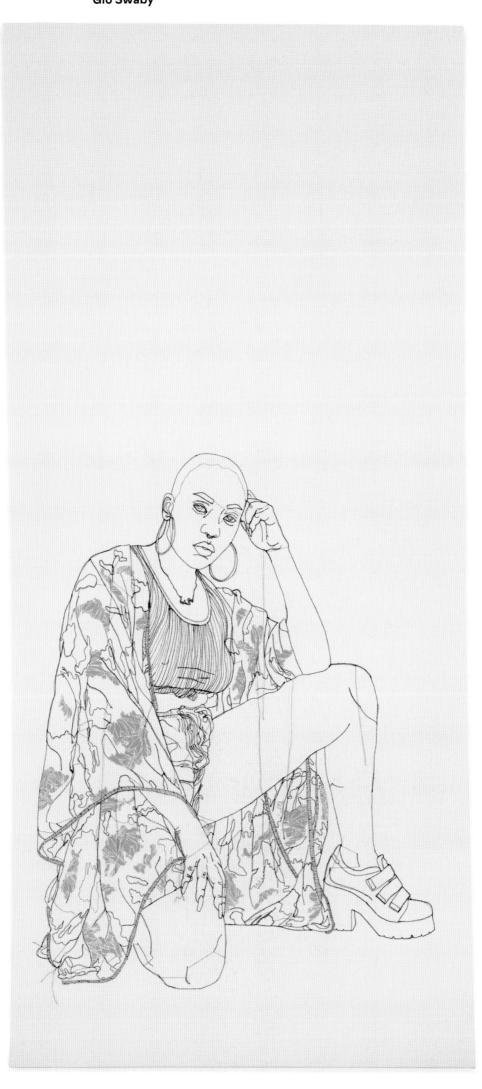

Pretty Pretty 9, 2021
Thread and fabric sewn
on canvas
83 × 36 inches
Art Institute of Chicago,
Barbara E. and Richard J.
Franke Endowment Fund,
2021.400

→
Pretty Pretty 12, 2021
Thread and fabric sewn
on canvas
84 × 38 inches
Courtesy of the Artist
and Claire Oliver Gallery,
New York

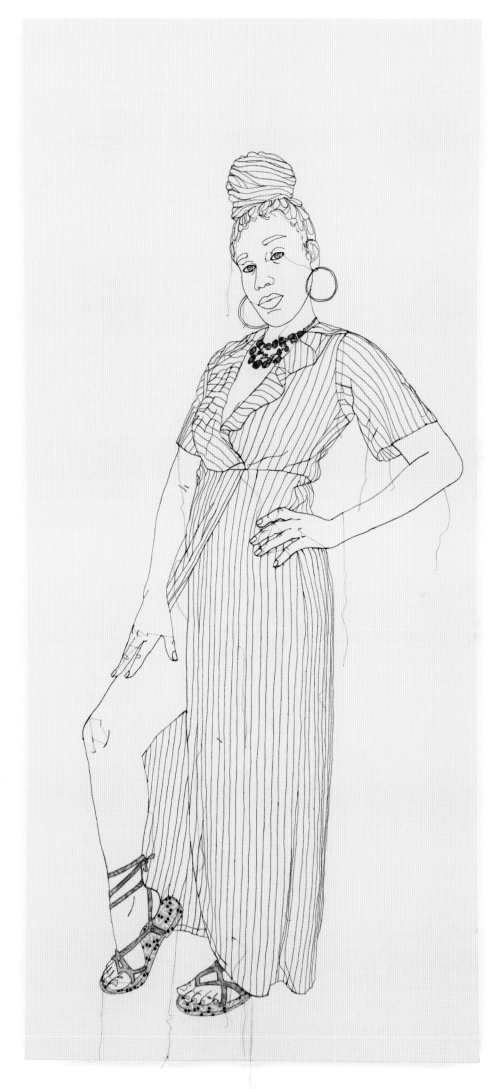

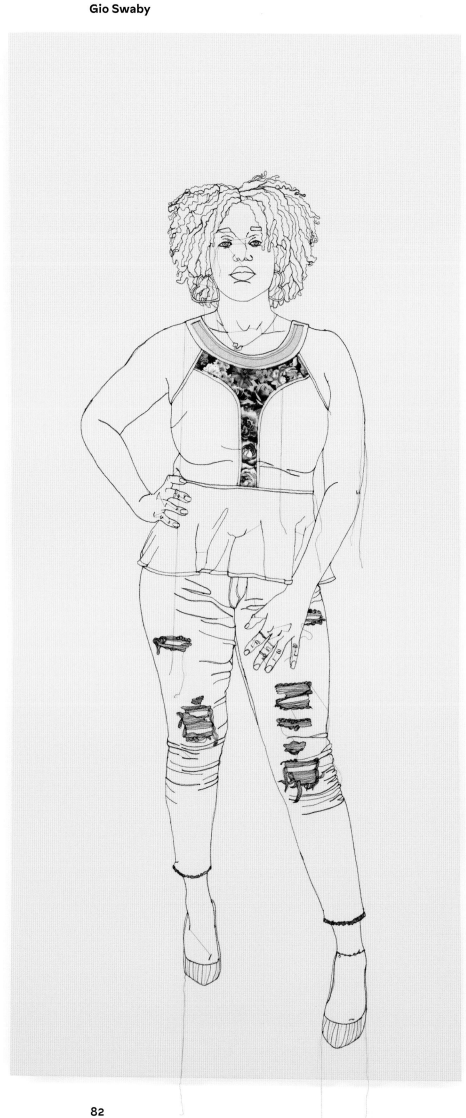

Pretty Pretty 10, 2021
Thread and fabric sewn
on canvas
84 × 38 inches
Courtesy of the Artist
and Claire Oliver Gallery,
New York

→
Pretty Pretty 11, 2021
Thread and fabric sewn
on canvas
84 × 38 inches
Courtesy of the Artist
and Claire Oliver Gallery,
New York

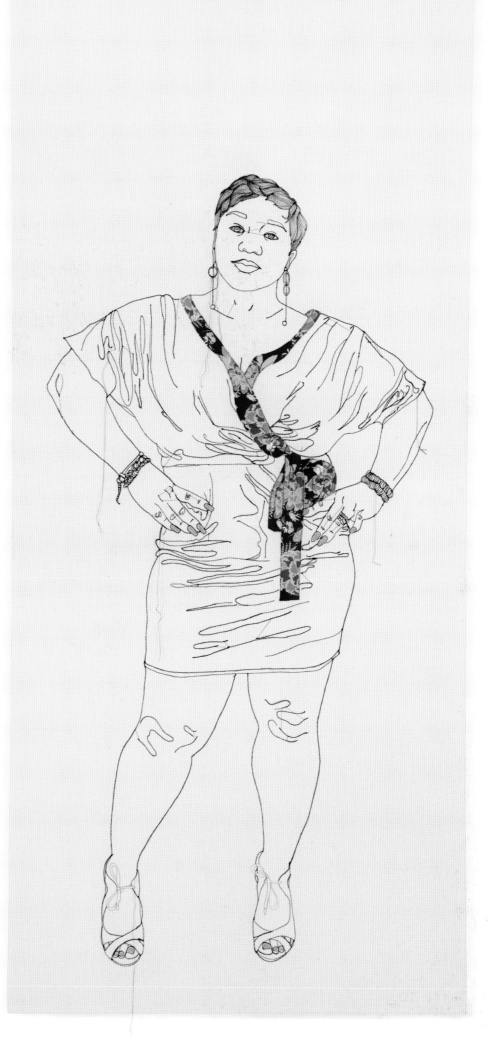

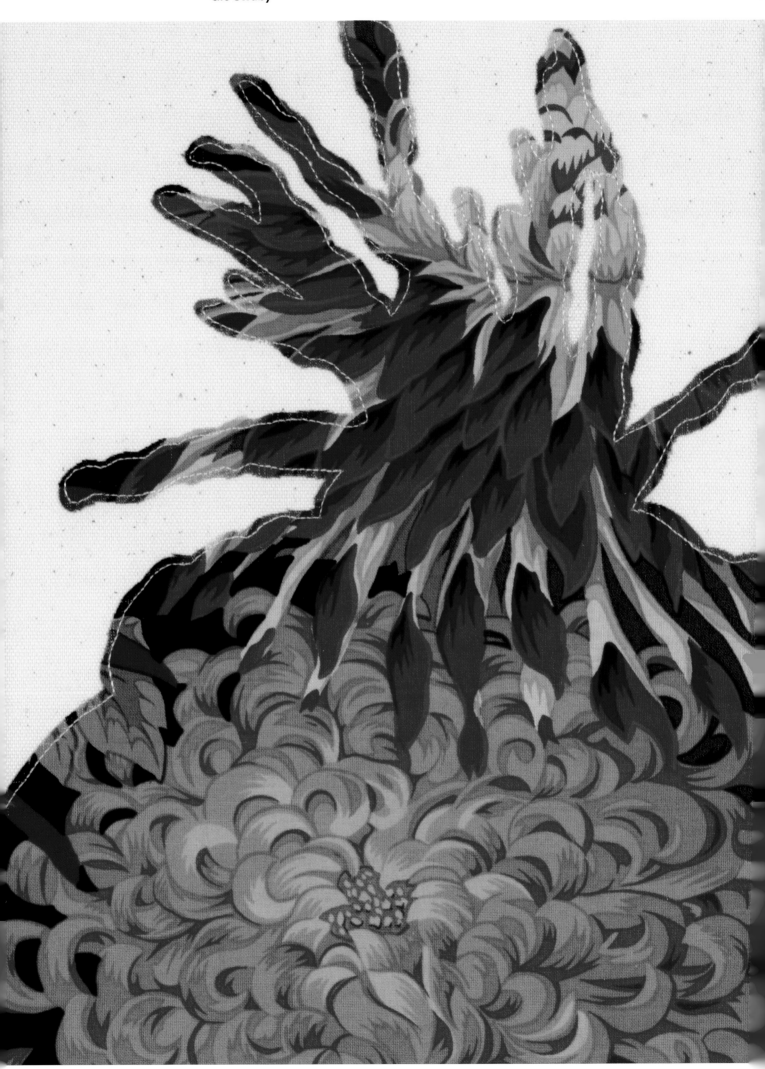

New Growth

New Growth is an ode to Black hair and the magic that it truly is. This series is an homage to the unique beauty of Black hair and celebrates the depth of skill and creativity that gives rise to such a vast and ever-growing catalogue of styles. Beyond the versatility of styling, this series honors the activation of ancestral knowledge through the act of hair-care. I see my hair as a physical connection to my lineage; it gives me a glimpse into the existence of my ancestors whose personal histories were buried in colonial retellings. I see caring for my hair as a pathway to recon-nection. A pervasive colonial standard of beauty can overwhelm us with trauma and shame connected to our hair. This series is a way for me to contribute to the continued efforts of repositioning Black hair as a beautiful extension of ourselves to be cared for with love and held in the highest regard.

Detail of *New Growth Second Chapter 3*, 2021

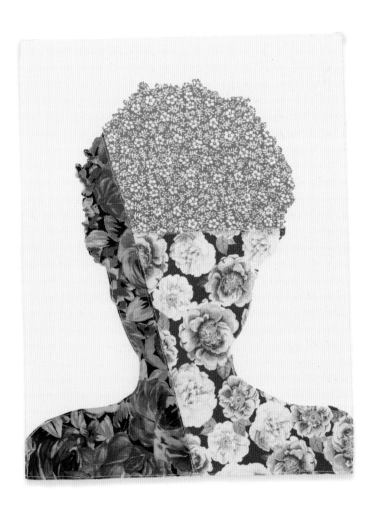

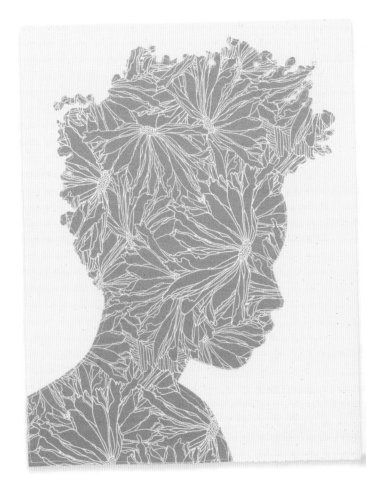

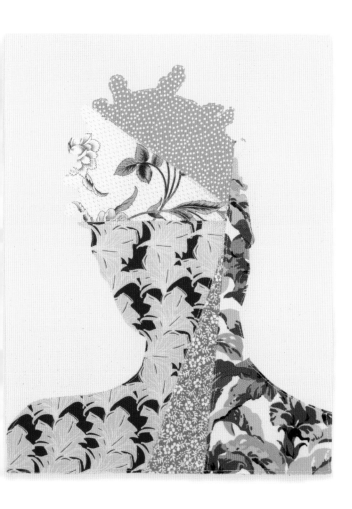

New Growth 1 (triptych), 2021
Thread and fabric sewn
on canvas
14 × 36 inches
Private Collection, New York

New Growth 2 (triptych), 2021
Thread and fabric sewn
on canvas
14 × 36 inches
Collection of Rasheed Newson
and Jonathan Ruane

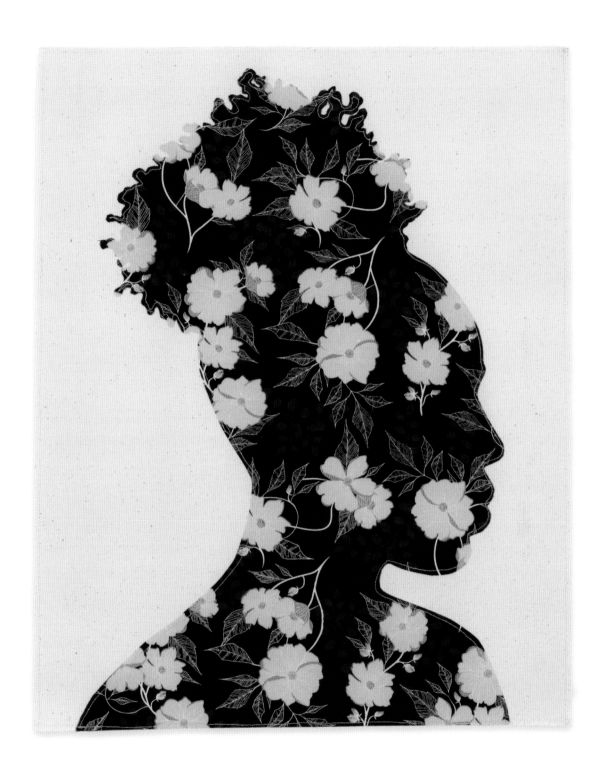

↖
**New Growth Second
Chapter 3**, 2021
Thread and fabric sewn
on canvas
20 × 16 inches
Collection of Claire Oliver
& Ian Rubinstein

**New Growth Second
Chapter 4**, 2021
Thread and fabric sewn
on canvas
20 × 16 inches
Collection of Claire Oliver
& Ian Rubinstein

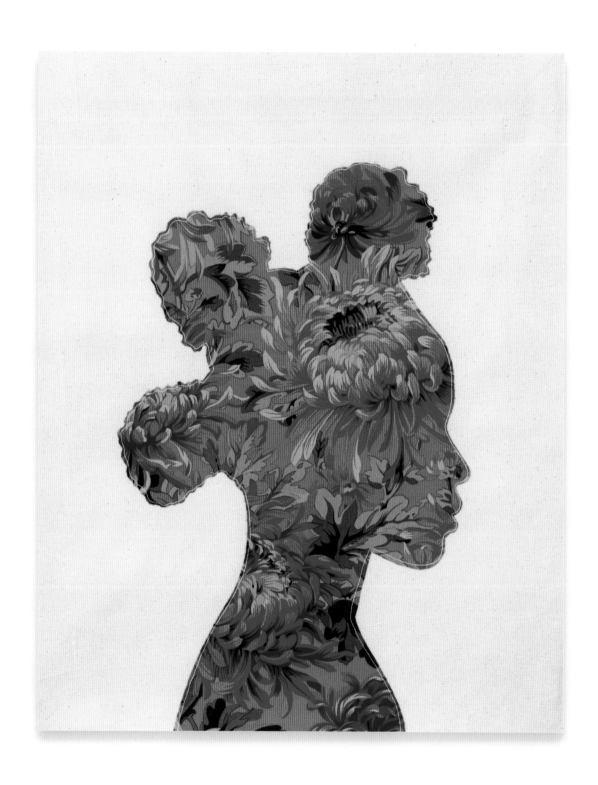

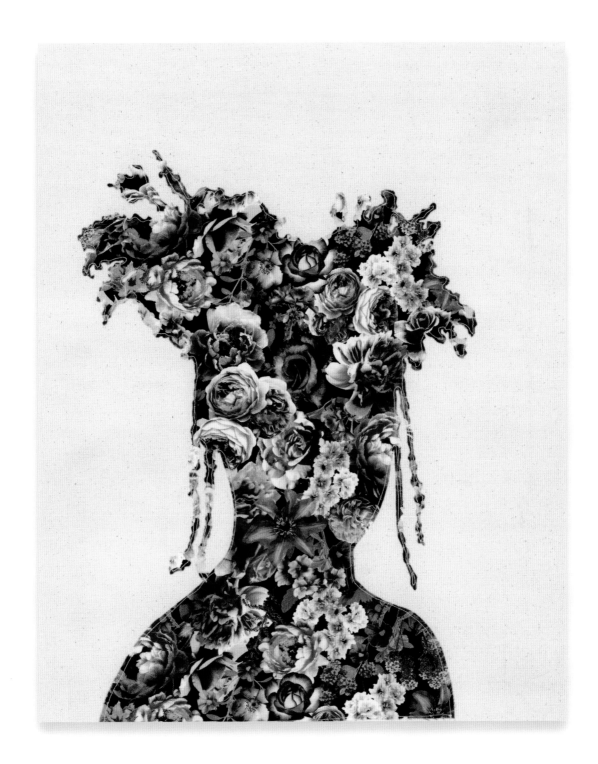

↖
**New Growth Second
Chapter 7**, 2021
Thread and fabric sewn
on canvas
20 × 16 inches
Collection of Jarrett and
Miriam Annenberg

**New Growth Second
Chapter 8**, 2021
Thread and fabric sewn
on canvas
20 × 16 inches
Collection of
The Altman Family

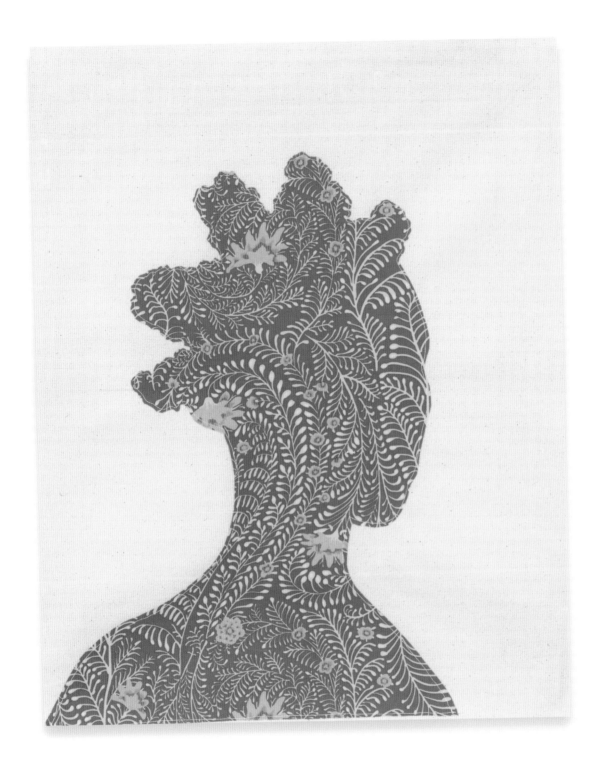

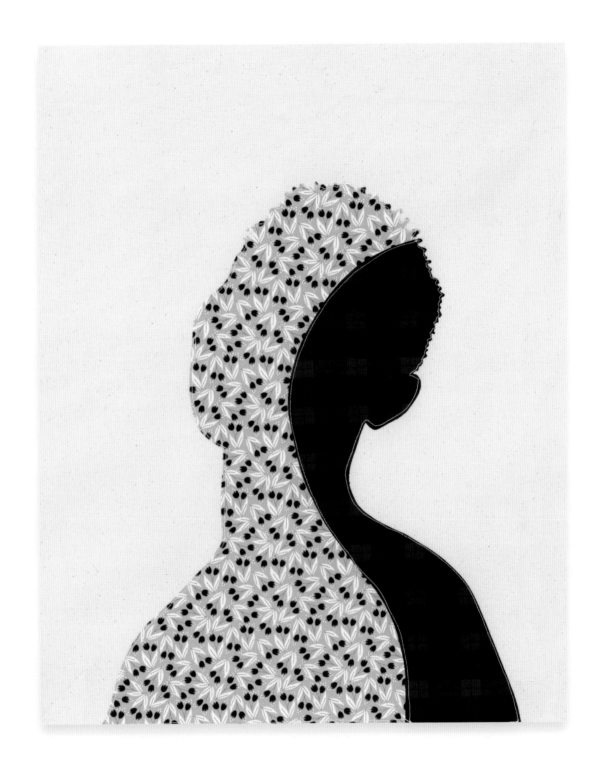

↖
**New Growth Second
Chapter 9**, 2021
Thread and fabric sewn
on canvas
20 × 16 inches
Collection of
The Altman Family

**New Growth Second
Chapter 10**, 2021
Thread and fabric sewn
on canvas
20 × 16 inches
Collection of Tatiana
Roth

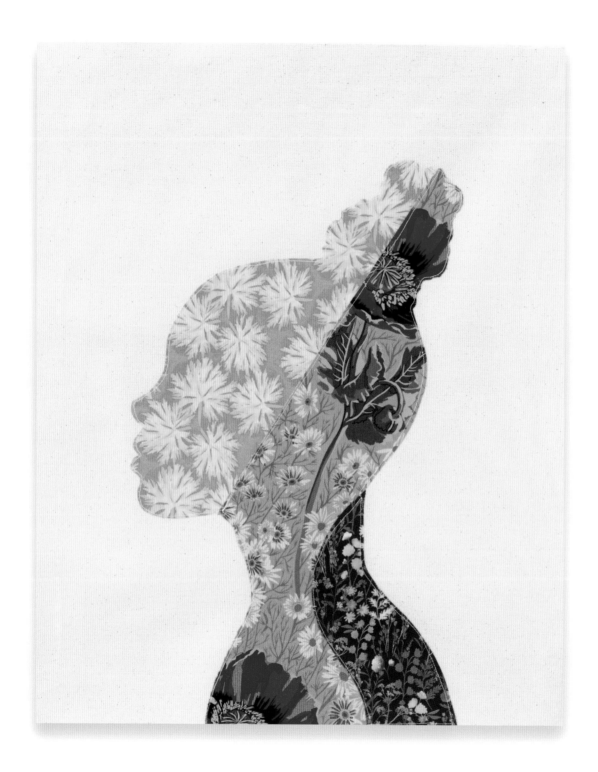

New Growth Second
Chapter 11, 2021
Thread and fabric sewn
on canvas
20 × 16 inches
Collection of
The Altman Family

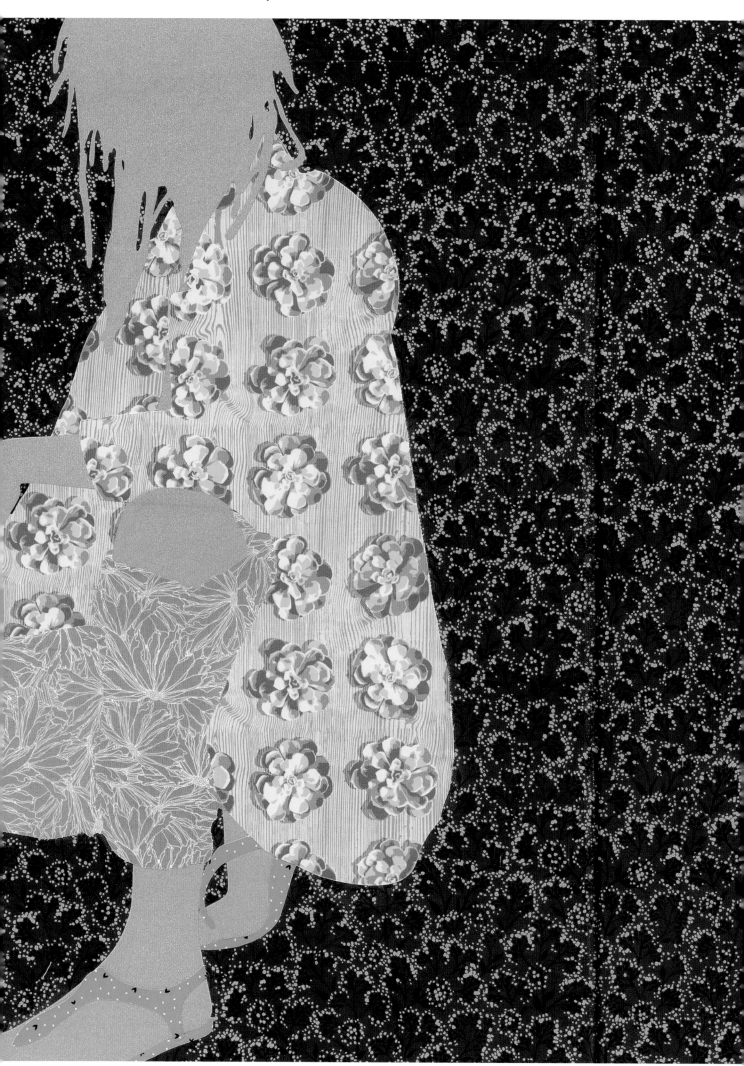

Gyalavantin'

It is a healing experience to reconnect with your loved ones after being separated for an extended period of time. One of the things I longed for most throughout the COVID-19 pandemic was to reconnect with my family and friends in the Bahamas. Of course, there were innumerable calls and video chats that helped stave off the yearning. However, there are some things that just can't be replicated virtually, like sipping sky juice at Arawak Cay with your good sis or eating a breast snack (fry dry, dry, dry!) with your niece in the Bamboo Shack parking lot. I missed the restorative connection that gathering and sharing physical space has to offer and creating this piece was a mode through which I accessed that connection. In some ways, *Gyalavantin'* laments the time that we have lost with one another, but it also looks forward to a future of safely reconnecting.

Detail of *Gyalavantin'*, 2021

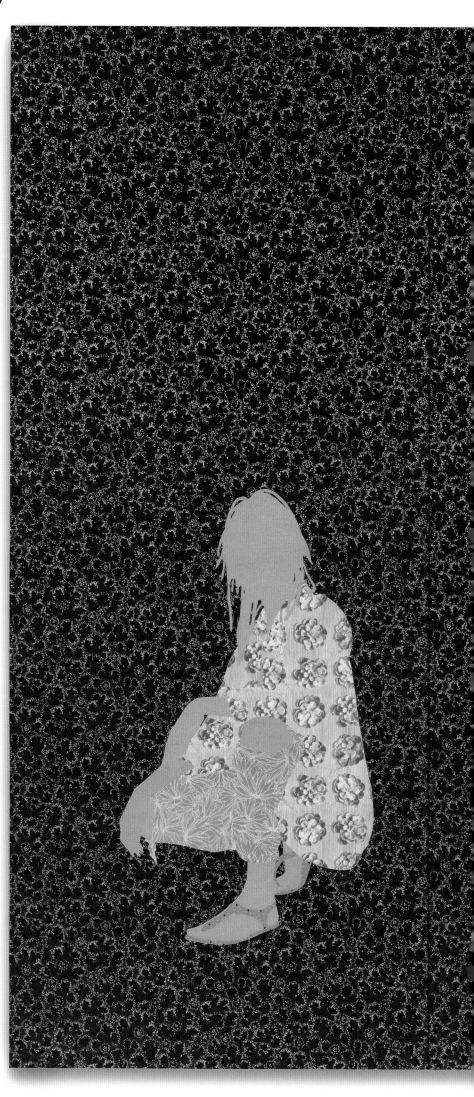

Gyalavantin', 2021
Thread and fabric sewn
on canvas
114 × 90 inches
Courtesy of the Artist
and Claire Oliver Gallery,
New York

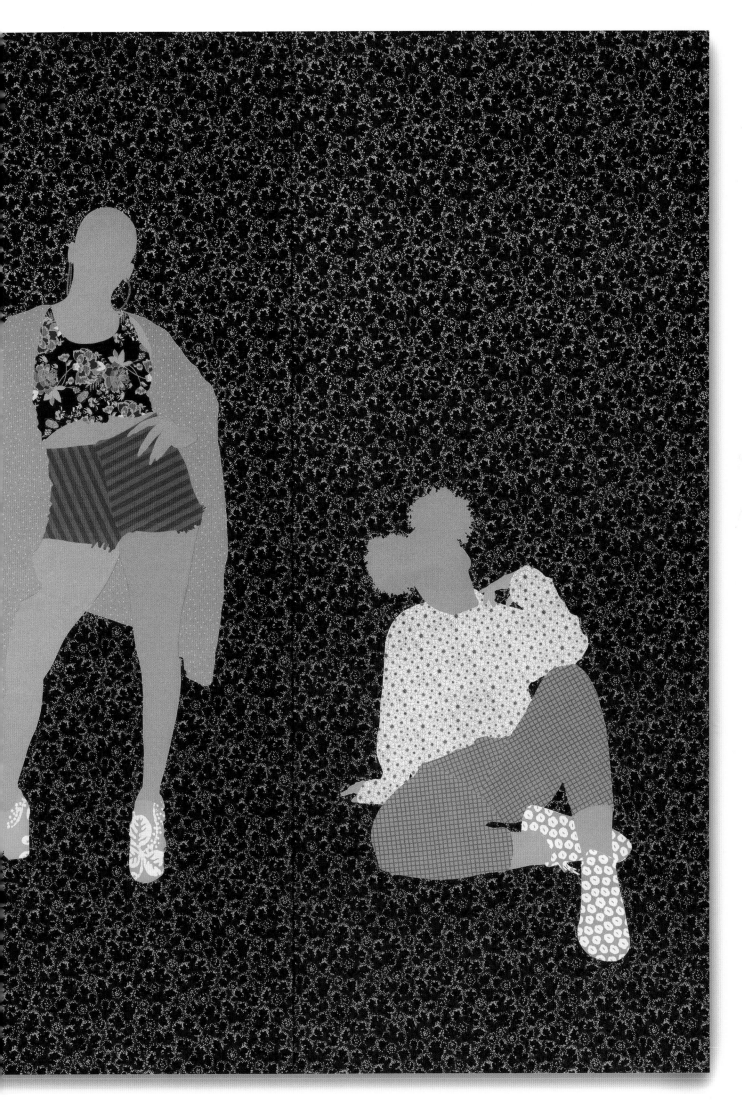

Artist Biography

GIO SWABY (b. 1991, Nassau, Bahamas) earned an associate of arts degree in art from the University of the Bahamas, Nassau, and a BFA in film, video, and integrated media from Emily Carr University of Art + Design, Vancouver, British Columbia. She is expected to receive an MFA in interdisciplinary art, media, and design from OCAD University, Toronto, Ontario, in spring 2022. Her work has been exhibited internationally and is included in private and public collections throughout the United States, including the Art Institute of Chicago; Minneapolis Institute of Art; Museum of Fine Arts, Boston; Museum of Fine Arts, St. Petersburg; and the Weisman Art Museum, Minneapolis.

Contributor Biographies

NIKOLE HANNAH-JONES is an award-winning journalist who focuses on civil rights and racial injustice for *The New York Times Magazine*, where she founded the Pulitzer Prize-winning 1619 Project. She holds the position of Knight Chair in Race and Journalism at Howard University in Washington, D.C., and in 2017 was the recipient of a MacArthur Fellowship. In 2015, she co-founded the Ida B. Wells Society for Investigative Reporting, with the intent to grow the number of reporters and editors of color. Hannah-Jones earned a BA from the University of Notre Dame and an MA from the University of North Carolina.

KATHERINE PILL joined the Museum Fine Arts, St. Petersburg as the museum's first curator to focus on modern and contemporary art and has organized exhibitions including *Marks Made: Prints by American Women Artists from the 1960s to the Present*; *Benny Andrews: Mix Master*; and *Shana Moulton: Journeys Out of the Body*. Pill previously held the position of assistant curator at the Kemper Museum of Contemporary Art in Kansas City, Missouri. She is a founding member of the feminist art collective Cunsthaus in Tampa, Florida, and earned a dual MA in art history and arts administration from the School of the Art Institute of Chicago.

MELINDA WATT has been Chair and Christa C. Mayer Thurman Curator of the Textiles department at the Art Institute of Chicago since June of 2018. In this role, she oversees the global textile collection and leads the textile exhibition program within the department. Previously, Watt was a curator at The Metropolitan Museum of Art, as well as supervising curator of the Antonio Ratti Textile Center. As co-curator of *Interwoven Globe: The Worldwide Textile Trade, 1500–1800*, she developed an abiding interest in the global artistic and technical exchange that has informed textile design throughout history and up to the present day.

Gio Swaby: Fresh Up was published in conjunction with an exhibition of the same title held at the Museum of Fine Arts, St. Petersburg, Florida, from May 28 to October 9, 2022, the Art Institute of Chicago from April 8 to July 3, 2023, and the Peabody Essex Museum, Salem, Massachusetts, from August to November 2023.

First published in the United States of America in 2022 by
Rizzoli Electa
A division of Rizzoli International Publications, Inc.
300 Park Avenue South
New York, NY 10010
www.rizzoliusa.com

Copyright © 2022 Museum of Fine Arts, St. Petersburg, Florida, and The Art Institute of Chicago

For Rizzoli Electa:
Charles Miers, Publisher
Margaret Rennolds Chace, Associate Publisher
Ellen R. Cohen, Senior Editor
Alyn Evans, Production Manager

Design: Barbara Glauber / Heavy Meta
Photo Retouching: Wilson Santiago

For Museum of Fine Arts, St. Petersburg:
Katherine Pill, Curator of Contemporary Art
Bridget Bryson, Senior Manager of Curatorial Affairs & Communications

For the Art Institute of Chicago:
Melinda Watt, Chair and Christa C. Mayer Thurman Curator, Textiles
Megan Rader, Executive Director, Exhibitions

This exhibition and catalogue are made possible by the generosity of the following individuals and organizations:

Elizabeth F. Cheney Foundation
Collectors Circle of the Museum of Fine Arts
Garth Family Foundation
Gobioff Foundation
Sonia Raymund Foundation
James G. Sweeny

2022 2023 2024 2025 2026 / 10 9 8 7 6 5 4 3 2 1

ISBN: 978-0-8478-7173-5
Library of Congress Control Number: 2021949796

Printed in China

Photograph Credits: All photographs of works by Gio Swaby, including details, are by Ian Rubinstein, unless otherwise noted.
p. 22: Photo by Joseph Hyde
pp. 98–102: Photos by LF Documentation

Front Cover:
Detail of *My Hands Are Clean 4*, 2017

Back Cover:
Detail of *Love Letter 3*, 2021

Frontispiece:
Detail of *Pretty Pretty 8*, 2021

Page 4:
Detail of *Pretty Pretty 9*, 2021